surprisingly interesting

A BOOK ABOUT

CONTRACTS

Sarah Conley Odenkirk

surprisingly interesting

A BOOK ABOUT

CONTRACTS

Sarah Conley Odenkirk

AMERICAN MODERN **BOOKS**

TABLE OF
CONTENTS

THE KEY

Guide to the symbols you'll find throughout this book:

LEGAL TALES
Anecdotes inspired by personal experience

RULE OF THUMB
Pay extra attention!

DEFINITIONS & "BTWS"
Definitions and noteworthy by-the-ways

KEY POINTS
Chapter summaries and important points

ACKNOWLEDGMENTS

I DECIDED TO WRITE THIS BOOK a number of years ago for two reasons. To begin with, I found myself giving the same lectures over and over again to artists who sought my advice on contract matters, which in itself seemed inefficient. But to make matters worse, I had to charge each of these artists for the time it took me to repeat myself. My guilt in creating more financial pressure on people who already have more than their share led me to regularly and dramatically discount my fees. Worse yet, I found myself accepting all manner of baked goods and other bits and pieces in lieu of cash. This was not a sustainable business model, especially for someone who was supposed to be encouraging good business practices.

The answer seemed to be either to get all the creative people with contracts questions together in one room so that I could expound on general contract issues one time, or put everything into a book that looked interesting enough to entice people to read it before coming to me for advice. As getting all creative people with contracts questions in one room for a single lecture presented numerous time and space challenges, I opted to write the book instead.

Little did I know the time and space challenges presented in writing a book—even a relatively little one! In addition to having to coherently commit my thoughts to writing, the arrival of my two precious children during the course of this project proved more than a little distracting. As did the continued demands of my fascinating-yet-demanding practice.

After more years than I would like to admit, I finally had a draft that I was willing to share with close friends, trusted advisors, and a few clients who have taught me as much as I've advised them over the years. They all devoted an incredible amount of time and effort to give me their thoughts, notes, editing suggestions, and encouragement. I could never have finished this project without their

valuable input. Thank you Rae Mahaffey, Larry Kirkland, and Joe Biel—your artist perspectives were invaluable. Thank you Richard Greenstone for your insight and legal brilliance. Your friendship is invaluable, especially when it means I can call you for help on projects like these. Enormous gratitude to acclaimed author M.G. Lord, Shannon Halwes, and Edward Burch for insightful editing and proofing. Thank you to Tracy Saritzky, who helped reformat and proof the manuscript at seminal stages. Thank you especially to my dear friend and writer Huck Barkin, who sat with me over many weeks to go through the manuscript line by line to make sure that my version of plain English jibed with that of a non-lawyer. I am terribly sad you are not here to see the finished product, but I am so grateful for the time we spent together.

Great appreciation also goes to Joe Biel who drew the illustrations found throughout this book. Joe's work often contains a compulsive or disturbing edge, which I am happy to say I relish. Joe himself, however, is charming, talented, generous, and kind, and he shows no signs of the compulsiveness his work displays. As he so rightly points out, this is irrefutable proof that art is indeed therapeutic.

Tremendous gratitude to Kimberly Varella, who did an amazing job designing this book. Her vision for making this book visually appealing has added a whole new level of interest and accessibility to subject matter that I reluctantly admit can, on rare occasions, be a bit dry. She is not only talented but took this task on under incredibly unfortunate circumstances. The original designer on this project, Justin Van Hoy, tragically passed away before completing his work on this book. Justin was an amazing and talented young man with whom I am honored to have worked. He was not only an artist in his own right, but also an active arts advocate. The world lost a rare and wonderful person when Justin died.

A big thank you to the folks at AMMO Books. Sara Richmond put in many hours reading and proofing at all different phases of this project. Steve Crist generously gave his expert advice on many occasions. Paul Norton and Tinti Dey supported this project from the first mention of it all those years ago. Thank you all for making this project possible in such a high-quality way. It means so much to me that you believe in the project enough to include it with your other truly amazing books about art, design, and creative culture.

Thank you to my wonderful, talented, and brilliant husband/prince charming, Bill Odenkirk, for giving me endless support and encouragement to get through the painful process of writing that you know all too well. You are the love of my life. Of course, finishing this book might not have taken so long if you hadn't also given me our little darlings, who have no interest at all in mommy's need to dissect contracts. Nevertheless, I thank them too for teaching me patience over and over again—a skill that was invaluable in finishing this book—and for going to bed promptly at 8 p.m. tonight so that I could get this last bit of the book written.

Finally, what Oscar acceptance acknowledgments would be complete without a teary thank you to my intellectually rigorous parents, whose own academic achievements I can never hope to attain, but whose approval of this work is so important to me. Thank you, Mom and Dad, for your support, encouragement, love, and unfiltered, but almost always correct, advice on this project and the 30-plus years of guidance that preceded it.

SARAH CONLEY ODENKIRK
Los Angeles, California
2014

IMPORTANT LEGAL DISCLAIMER

In order to keep you, the reader, engaged and to show you how complicated legal issues apply in real situations, I've included a number of stories throughout this book. These stories are compiled from my real experiences as a lawyer, but in order to protect client confidentiality, most, if not all, facts have been changed, manipulated, and reworked to make the stories essentially fiction.

As I changed everything to specifically *not* resemble any particular client or real situation, any resemblance to actual events, locales, or persons, living or dead, is entirely coincidental. Please do not spend any time trying to figure out the "true" identities of artists, galleries, developers, or other characters featured in my stories (you can't because they're not real.) You will not discover any exciting gossip in this book—though come to my book signings, and I'll see what I can do. Spend your time instead exploring and mulling the concepts discussed. You'll find this much more satisfying and profitable.

Trust me . . . I'm a lawyer.

Chapter 1

THE CONTRACT
CONUNDRUM

FOR MOST PEOPLE, reading a contract conjures up feelings of dread rather than elation—perhaps even more so for artists. And who can blame them? Nevertheless, if you are going to succeed as a creative person in a business world, you must come to terms with the need to balance your aesthetic sense with business savvy. A passive approach will only cut you out of the decision-making process. Conquer the contract! Take control of your career! An active one will open doors and lead to more business opportunities.

A Surprisingly Interesting Book About Contracts offers simple explanations in plain English. It will give you the tools to be in the best possible position to maintain control of your work and achieve career success. And you may even begin to enjoy the business of artistic practice.

If you are an emerging artist, it's hard enough to earn a living without having to slog through a lot of legal and business stuff. If you are a more established artist, you may be feeling worn down by the constant need to deal with legal and business issues or the confusion that can ensue when these issues are not addressed up front. Take heart! You are not alone. No matter where you are in your career, you need not feel overwhelmed. These issues are complex and take time and energy. While you must have a handle on contract matters, you don't have to figure them all out on your own. Luckily, there are people who dedicate their careers to offering legal and business advice to artists like you. But, in order to effectively retain and benefit from their counsel, you must know what questions to ask.

Your ability to choose a team wisely depends on your grasp of the relevant legal and business issues.

While it makes sense to delegate the work of interpreting, drafting, and negotiating deals to someone else, you still need to know exactly what it is you are delegating. Having a solid understanding of contracts and business strategy, if only at a basic level, is indispensable in wading through the legal swamp.

So, who am I to help you? Early on, I honed my skills as a civil litigator and general business attorney, but I never lost sight of my desire to focus on the arts. Over time, my personal passion for the arts and my legal training merged and evolved into a successful practice made up almost exclusively of artists and art-related businesses.

My work took me to Los Angeles, where I established a practice in Beverly Hills. My practice grew and remained focused on the visual arts with a particular interest in emerging artists. However, recognizing both the emotional and financial barriers artists face when seeking legal advice, I found the most effective help I could offer was teaching workshops for artists and mentoring young attorneys interested in the arts. Artists often lacked basic knowledge about business and intellectual property but always seemed eager to learn. And I, as an art lawyer, could make a difference.

Despite the growing popularity of "art law" as a specific area of practice, artists and lawyers alike are frequently unclear as to what exactly it is. It sounds sexy enough—but in fact, being an effective art lawyer means having a solid background in a broad range of basic business and intellectual property issues and understanding how they apply specifically to the arts. Perhaps equally important is the ability to communicate in a clear way and connect with creative people. What I recognized in hindsight was that the years of legal experience I thought of as irrelevant early in my

career were, in fact, exactly what made me a successful art lawyer. I liken it to artists needing to master basic drawing skills before creating effective abstractions.

My interest in the arts and in providing guidance to artists led me to teach many seminars in several different contexts. One of the most inspirational settings was CalArts in Valencia, California. During the course of several years, I taught weekend seminars to alumni on issues ranging from contracts to copyrights, and trademarks to corporate structures.

People came to my seminars with a sense of obligation, hoping to stay awake long enough to glean something useful. Yet, at the end of each seminar, many attendees would tell me how much they enjoyed the session and how they had found the subject material more interesting than expected.

An idea began to form: Could I write a book inspiring the same level of enthusiasm and interest as I had in my seminars? I decided I had to try.

This book is an antidote to those lawyers who jealously withhold clear explanations of even the most basic legal concepts. Obfuscating simple ideas makes the process of achieving a successful written agreement appear to be out of reach to even the most thoughtful non-lawyer. This approach to serving clients frustrated me since the beginning of my law practice and fueled my desire to contribute to the education of artists and other creative people.

This book is the distillation of many years of research, advising, teaching, writing, and, of course, thinking. I have condensed a great deal of information into a form you will be able to refer back to. Over time, as you become more comfortable with the material in this book, you will probably find you need to consult this book less frequently. As you further your under-

standing of the concepts presented here, you will also develop your ability to think critically about the business issues integral to being an artist.

Whether you are an artist, or any other sort of creative person, you should finish this book with a knowing smile, having painlessly achieved a better understanding of how artists and the legal community can work together to protect artists' rights. And if we are to believe Winston Churchill, who said, "true genius resides in the capacity for evaluation of uncertain, hazardous, and conflicting information," then used properly, this book should also make you a genius.

READY, SET, GO!

So now what? Where do we start? Do you really need a lawyer, or can you do this on your own? Before we dive headlong into the nitty gritty of contracts, we'll first explore some common myths and misconceptions. Next, we will take a look at the lawyer-artist relationship so you feel comfortable deciding whether to hire representation or go it alone. Then, we'll explore how contracts evolve. Understanding how a contract is created and what it looks like will give you the skills to confidently and effectively participate in nurturing a successful career in the arts, with or without the support of a lawyer.

MYTHS & MISCONCEPTIONS

IF IT'S NOT IN WRITING, IT'S NOT VALID.

☐ True ☐ False ☒ Mostly False[1]

Many oral contracts are, in fact, valid agreements; the problem is enforcing them. If you make a deal with someone and later have a disagreement, without something in writing, it will likely be your word against his or hers. If the disagreement goes to court, you will probably be allowed to present whatever evidence you have to prove your position. However, now you're in the difficult position of having to prove everything as opposed to having a document to rely on for the parameters of your agreement. One important exception is a transfer of copyright, which must be in writing to be valid. More on that later on page 95.

WE'RE BOTH REASONABLE, HONEST PEOPLE, AND A HANDSHAKE IS GOOD ENOUGH. (OR WORSE YET: WE'VE BEEN FRIENDS FOR YEARS ...)

☐ True ☐ False ☒ Questionable, at best

Many disputes arise between honest, well-meaning people who have totally different recollections of what

1. Except those covered by the legal requirement called the Statute of Frauds, which generally covers: Contracts in consideration of marriage; Contracts that cannot be performed within one year; Contracts for the transfer of an interest in land; Contracts by the executor of a will to pay a debt of the estate with his or her own money; Contracts for the sale of goods above a certain value, which is currently $500; Contracts in which one party becomes a surety (acts as guarantor) for another party's debt or other obligation.

the "deal" was. Unfortunately, the nature of the art business is that the people involved and the subject matter at issue tend to be of a more emotional nature, so disputes may become personal quickly, leading to a more difficult situation to resolve. There is no better way to end a good friendship than to have an emotional contract dispute.

ALL CONTRACTS ARE COMPLICATED AND FORMAL.

☐ True ☐ False ☒ Not completely true

Some certainly are, but they don't need to be. A contract can consist of a simple writing that embodies the key elements of your agreement with someone. There's no need for formal legal language; everything can be put into understandable terms, and if it is not, you should request that it be rewritten so that you can understand it. <u>Certainly, you should never sign anything you don't read and fully understand</u>.

EVEN THOUGH THE CONTRACT DOESN'T SAY IT, I WAS PROMISED [___] VERBALLY.

☐ True ☐ False ☒ Doesn't matter

If the contract has what is called an "integration clause," and you are hoping to get something that is not spelled out in the contract, you are probably in trouble. An integration clause indicates that the written

deal is all there is, and any other agreements not in the contract are invalid. This is a standard term in many agreements and will be difficult to get around later, so do not fall for the sweet-talker who promises the sun, moon, and stars when the words in the contract promise you a warm cow pie. "Don't worry about what it says in the contract; I'll make sure that you get blah, blah, blah." You won't.

The other instance where this may be important is when there is an oral modification promising you something new or different. If the contract states that amendments can only be in writing, then an oral amendment will not do you any good. Even if the contract doesn't require writing to amend, this brings us back to our oral contract dilemma of proving and enforcing oral promises.

YOU CAN MAKE A CONTRACT FOR ANYTHING!

☐ True ☐ False ☒ True, sort of

Sure, you can write up a contract for anything, but a contract for an illegal transaction will not be recognized as valid by the courts. For instance, you will not have any luck in court recovering payment for transporting cocaine from Los Angeles to New York, whether you had a contract or not.

CONTRACTS ARE JUST LITIGATION TOOLS.

☐ True ☐ False ☒ Not completely true

A more constructive view of contracts is to see them as tools for communicating. The beginning of a business relationship is the best time to determine if everyone is in agreement on terms and obligations. Use the contract negotiating and drafting process to establish, define, and clarify your expectations so that the chance for problems later on is minimized.

KEY POINTS

Before we move on, let's review:

» Although oral agreements may be valid, it's best to have everything in writing.

» Contracts need not be viewed as a prelude to litigation, and, in fact, may be the best way to preserve friendships.

» Contracts can be written in plain English.

» Side deals or oral amendments may be a problem, so be sure to include all terms in the contract and confirm any changes in writing.

» Finally, valid contracts must be for a legal transaction.

Chapter 3

DO I EVEN NEED A LAWYER?

JANE AUSTEN WROTE IN *MANSFIELD PARK*: "We have all a better guide in ourselves, if we would attend to it, than any other person can be." A much more eloquent way of saying, "Trust your gut." The point: Don't ask someone else if you need a lawyer; ask yourself. If you feel uncomfortable, out of your element, or over your head when it comes to reading, interpreting, and negotiating your own business deals, then the answer is probably a resounding "YES!"

If you're exceedingly clever (or foolish—you can decide later), you may choose to negotiate your own deal without spending a cent of your money or a minute of your time on a lawyer. Even then, it's wise to have an established relationship with a lawyer—just in case. That way, if you find yourself uncomfortable with the negotiations, things are getting more complicated than you anticipated, or you discover halfway through the deal that you were indeed foolish and not clever, you have someone to call.

Remember, you may have a form contract that works for your situation, but without a lawyer you don't have the benefit of the experience that went into drafting the form. You also may not have the experience to edit the form effectively to include the nuances of your particular project.

In addition to interpreting documents, lawyers can act as a buffer in the negotiation process, which can go a long way to preserve delicate art world relationships. How convenient is it to use your lawyer as an excuse for taking time to review a document or ask for changes?

"Penny-wise and pound-foolish" was never more applicable. Spending a few dollars to have a contract reviewed at the beginning of a deal, or having a lawyer handle the sensitive areas of negotiations, is far easier and less expensive than waiting until an actual problem arises.

HOW DO I FIND THE RIGHT LAWYER FOR MY PARTICULAR SITUATION?

Sometimes it's clear from the start of a deal that you're going to need help. Or maybe you feel like you're at a place in your career where it makes sense to establish a relationship with a lawyer for general business purposes. In any case, once you've decided that it's time to work with an attorney, there are several important pieces of information you should keep in mind. Understanding the basic principles of the attorney-client relationship will help you develop a sustainable, and perhaps even friendly, relationship.

Finding the right fit can be complicated, which is why you have to ask lots of questions and pay attention to your gut. You are the client! This means that you are in charge. When you hire a lawyer, you are hiring someone to represent what *you* want—within reason, of course. It's important, so it makes sense to interview a number of people until you find someone who meshes well with your needs and temperament, even if that's just a "good feeling" you get from an initial meeting. Like with your doctor or accountant, you will likely share personal information. Thus, it's crucial to make sure you're comfortable with the lawyer you choose.

So, where do you look if there aren't any trustworthy lawyers in your family or book club? Before you start your Google searches, ask friends and colleagues for recommendations. Take all rave reviews with a grain of salt, but a well-founded recommendation can go a long way—especially if the person making the recommendation has dealt with situations similar to your own. It's also valuable

information if you get the same name more than once—either as a recommendation or a warning.

Once you gather your personal recommendations, the Internet is a powerful tool for further researching or adding to your list of possibilities. Not only can you search your local area for a lawyer or firm that fits your needs, but law practices often maintain detailed sites marketing their services. Find out what types of other clients a lawyer or firm represents, and you gain important insight into attorneys' or firms' backgrounds and interests.

Finally, you can contact your state or local bar association. Many maintain lists for referring potential clients to attorneys, and may also have lists of attorneys willing to provide legal services on a reduced or sliding fee basis. They may also be able to refer you to nonprofits that offer general legal services without the need to hire a lawyer. For instance, many communities have volunteer lawyers for the arts who provide free or inexpensive clinics, seminars on specific legal issues, written materials, or other affordable legal guidance.

Above all, ask lots of questions up front. That's the best way to ensure that you are hiring the right person, and that your attorney-client relationship gets off on the right foot. Make a list of questions to ask on the phone or at your first meeting. Let's go through some of the basics.

WHY SHOULD I HIRE YOU?

Most lawyers today are specialists. When it comes to matters concerning unique niches like the art world, it is vital to work with a lawyer who has specific experi-

ence in art-related matters. Often, you'll discover that these lawyers are also people for whom art plays a large role in their personal lives. So, don't be afraid to ask a lawyer about her particular experience with matters like yours.

WILL YOU DO AN INITIAL CONSULTATION BEFORE I RETAIN YOUR SERVICES?

Before you hire a lawyer, it's a great idea to meet him or her in person to ask your questions and see if it's a good fit. Phone conversations may go well, but when you meet someone in person, the interaction is quite different. That's where initial consultations come in.

Many people seem to feel that lawyers should do free initial consultations. But you have to remember that lawyers are selling their time and expertise, so as soon as you start receiving one or the other (or both) you will probably be expected to pay. Most lawyers will give you a few minutes for free over the phone, as long as you don't ask for specific legal advice, but generally will charge for an initial consultation, even if you don't hire them. If you end up hiring the lawyer, the fee for the initial meeting may be waived.

BOTTOM LINE: Be prepared to pay for an initial consultation, but understand you are *not* obligated to that hire lawyer.

The initial consultation is when you ask questions about the lawyer's fees, education, and experience, and perhaps get her thoughts on how to proceed when taking on a matter like yours. Do not try to squeeze out helpful advice without having to hire or pay the

lawyer. There's a sound reason that lawyers are leery about advising until they are hired: Specific advice can be considered providing legal services, and the lawyer thereby becomes potentially liable. So just try to get to know each other. Then, if you decide to retain the lawyer, you should receive a formal letter clarifying the terms of the representation, and you may be required to pay something up front as a retainer fee.

HOW MUCH IS THIS GOING TO COST?

<u>This brings us to the dreaded subject of money</u>. It depends on the lawyer and your needs. Attorneys charge in three main ways:

1. <u>HOURLY</u>

Most attorneys have an hourly rate, anywhere from $100 to $1,000 per hour, and in some rare cases more. For some attorneys, this rate is non-negotiable. However, others may negotiate, depending on the kind of legal work you bring to them and their estimate of how long it will take. Where the length of the project depends mostly on the response of someone else or his lawyer, it may be hard to judge how long the legal work will take. But it never hurts to ask. Just make sure you ask before the work begins and not once the bill has been sent out! Nine times out of ten, asking your lawyer for a discount once all of the work has been done is a sure way to damage your relationship. Talk money up front so no one is surprised by the outcome and no one feels taken advantage of.

2. <u>FLAT FEE</u>

If you have a piece of work for which the attorney can reasonably calculate the time to complete (such as a form

agreement for use in future projects), she may be willing to quote you a flat fee. However, if you need to negotiate a deal with a third party, it will be much harder to find someone willing to give you a reasonable flat fee deal since the amount of time it will take to negotiate the deal depends on the attitude of the other party.

3. CONTINGENCY FEE

In litigation matters, lawyers may be willing to take your matter on a contingent basis. This means the lawyer will take a percentage of what is recovered in the end. It is unlikely that you will find a lawyer to take your case on this basis if the dollar amount of potential damages is low. Unfortunately, people sometimes find themselves in a terrible situation where they've been treated badly and are obviously entitled to some sort of recovery. But if it's small, no matter how clear and egregious the wrong, it will be tough to find a lawyer willing to take it on contingency. Another important factor to consider will be whether there is an insurance policy in place. If there is, even if the dependent does not have the means to pay a judgment, there may be insurance money to cover a claim and maybe even the cost of the lawyer.

ANY OTHER COSTS?

Other than the attorney fees, you will probably also be responsible for all hard costs. These can range from postage and telephone charges to hiring outside experts. Costs for mail and phone calls should be minimal. Outside experts can be very expensive. Make sure you are consulted and completely aware of any such large costs beforehand.

WHAT IS A RETAINER?

When you hire a lawyer, she might require that you pay a retainer into a trust account. This may range from a few hundred dollars to several thousand. That money sits ready to be drawn on each month to pay your bill. You should receive a statement showing how much the bill is and that the money in trust has been applied. You will likely also be required to replenish the trust account to maintain a consistent balance. At the end of the representation, if any funds remain in the trust account, you should receive a check for that amount. On the other hand, you will be responsible for any money owed after all trust account funds have been applied to your final bill.

If you ever have questions about how trust funds will be held, or how the statements are generated, ask immediately so the confusion doesn't continue to grow. One question I've heard over and over: What happens to the interest? In most states, interest from lawyer trust accounts is paid by the bank to the state bar association to fund legal aid and other public legal support programs. For most people, it's enough just to know that the lawyer isn't benefiting from the interest, but if you are curious about the specifics in your state, contact your state's bar association for a full explanation.

The amount of a retainer varies according to the lawyer's assessment of how much work will be done each month and how many costs will be incurred. It also helps the lawyer decide how serious you are about maintaining a professional relationship and paying your bills. A client who cannot afford a reasonable retainer may be unable to keep up with monthly charges.

That said, the amount of the retainer is often negotiable. If an attorney asks for more than you can

immediately afford, explain that. Ask for a smaller retainer or a payment plan, so you can pay into the trust account regularly over a few weeks. While no attorney I know wants to work involuntarily for free, pretty much everyone appreciates an honest discussion about financial ability up front. Being honest about your ability to pay how much and when will go a long way to earning you some flexibility with your lawyer. Likewise, being consistent and trustworthy in adhering to any payment plan will build your credibility.

WHAT EXACTLY WILL YOU DO FOR ME?

When you hire an attorney, she should provide you with a letter confirming your representation agreement. This letter should provide complete explanation of the scope of work to be performed and fee policies. If later on you ask the lawyer for something not listed in the initial agreement, be sure to confirm how much it will cost. The lawyer may even send you a confirmation letter to cover the additional work.

In addition to the financial arrangements, you should also clearly understand the attorney-client privilege that begins when you retain a lawyer. Communication between you and your lawyer is generally privileged. That is, in most cases, your attorney is ethically prohibited from disclosing your secrets and confidences without your consent.

But note, and remember well, that privilege may be lost. Any voluntary disclosure of a significant part of a privileged communication will waive the privilege. For example, if you show a letter from your lawyer to someone else, even a relative, the privilege could not only be destroyed, but the communication could then become subject to discovery and examination at trial. Oral disclosure may also destroy the privilege.

To preserve privilege, you and your attorney must take reasonable precautions to avoid disclosure. Whenever possible, have discussions in person. Think hard before leaving a long voicemail or sending an email containing privileged or sensitive information.

WHAT IS REASONABLE TO EXPECT?

Like other professional relationships, an attorney-client relationship creates legal rights and obligations on both sides. For example, lawyers must be careful in agreeing to take on a client if there is a chance that representing that person will create a conflict of interest with other clients. Let's say I represent the Awesome Art gallery. I should not agree to represent any artist who is negotiating a consignment agreement with that same gallery.

Before you agree to be represented by a law firm, find out who your primary contact will be. Often, clients will meet with and think they are retaining a senior attorney, only to find out later that the junior associate will actually be handling their work. So, before any payments or signatures, be sure to understand who will be managing your matter, and obtain contact information. On the other hand, the judicious use of a bright junior attorney or a talented paralegal can save you hundreds, if not thousands, in hourly fees.

Effective representation by a lawyer is built upon a foundation of mutual trust and confidence. This is critical. Like any personal relationship, open communication is key to the health of the lawyer-client relationship. The quickest way for it to erode is through lack of communication, misunderstandings, or some combination of the two. A good lawyer should listen carefully to what you have to say, evaluate the situation based on her knowledge, and present your

options in plain English. Then, it is up to you to choose an action plan.

Someone should advise you of the status of your file on a regular basis to keep you up to date on all aspects. You should never have to wait more than 24 hours to hear back from your attorney or her assistant, even if it is just to let you know that she's busy with another matter and, assuming your matter is not urgent, will get back with you in another day or two.

Most misunderstandings, if frankly addressed, can be fixed. If you ever wonder about the progress of any matter your attorney is handling for you, or have questions about your bill, you should address those issues promptly before they escalate and become harder to resolve.

Your attorney should at all times work with your best interests in mind—namely, to balance your desired outcome with the most efficient and cost-effective resolution. But, she must operate within the bounds of the law and can only work with the facts. She needs all of the facts to develop a strategy. So, <u>it is crucial that you always tell the truth and share information about your matter, whether or not you think it is relevant</u>. Keep in mind, though, that the need for truth, honesty, and full disclosure is not synonymous with sharing every thought that passes through your head. You will find that consistent calls and emails will quickly eat through your retainer and result in a large bill.

One reason to hire an attorney is for a more objective view on matters about which you may be more emotional. So, it is possible that at some point your attorney will suggest a strategy, resolution, compromise, or course of action you do not agree with. It is important to listen to her reasons. It is equally important for her to understand why you may feel uncomfortable or

unsatisfied. Your attorney cannot force you to accept a
solution or course of action. You are the client, and it
is your matter. However, if your attorney feels that you
consistently ignore her legal advice, she may ask you
to seek new counsel. Likewise, if you feel that your
attorney is consistently ignoring your needs, you are
free to seek a second opinion and/or replacement
counsel. Keep in mind, though, that attorneys can only
negotiate and craft solutions and deals within
the bounds of the law and reality.

KEY POINTS

All of the above is crystal clear, of course,
but just in case ...

A few reminders

» Don't be afraid or ashamed to ask for help when you don't
understand a document or feel you're in over your head.

» Ask questions before you hire an attorney to help you.

» When deciding whom to hire, trust your gut.

» Attorneys can only work with the facts that exist. Don't
think that attorneys can work magic or that the facts change
if you withhold information.

» No matter how much an attorney loves art and artists, you
must be prepared to pay a reasonable fee.

Chapter 4

GETTING WHAT
YOU NEED

WILL ROGERS SAID: "The minute you read something that you can't understand, you can almost be sure that it was drawn up by a lawyer." True all too often. Nevertheless, it is always a bad idea to enter into an agreement you don't understand—no matter who wrote it. The first step in making contracts more accessible is to reject the notion that contracts are nothing more than a confusion tactic or litigation tool. Contracts should be an opportunity to communicate.

The mere mention of a contract can be a wet blanket on an otherwise exciting creative project. Artists don't want to destroy a chance for a show, kill a commission for a project, or scare away a collector by suggesting a written agreement. Art dealers don't want to interfere with the rapport they've built with an artist or a collector by mentioning a contract. Yet, written agreements happen to be the best way to make sure everyone is working toward the same goal with similar expectations. And that wet blanket of a contract can turn out to be warm protection if projects do not go as planned.

Sometimes, and especially in the art world, people are loath to commit their words to writing. Instead, they prefer to rely on a handshake to seal the deal. As we know from the previous discussion of Myths & Misconceptions, the real problem with oral contracts is that they are unreliable and leave ample room for actual or contrived memory gaps. It can be uncomfortable to convince someone to sign a contract when they prefer the old-fashioned handshake. But repeating the mantra to yourself and others that "contracts are an opportunity to communicate" should do the trick. If not, proceed with caution!

NAVIGATING THE HANDSHAKE

IMAGINE AN ARTIST whose dealer finds a collector who wants to buy several pieces at once. The collector, of course, expects a discount. Even so, the total sale comes to a generous seven figures. A simple agreement to clarify the details is at least a good idea. The artist agrees, but the dealer is reluctant to put anything in writing.

A cynical explanation is that the dealer wants the deal to be vague because there is something fishy about it or the collector, or the dealer wants to be able to change the deal as it suits him. But, an equally plausible explanation is that the dealer wants to close the deal quickly and feels that putting it on paper will make the collector nervous enough to back out.

Either scenario is a concern for the artist. When faced with this sort of situation, I try to push for at least having a simple one-page agreement that lays out the basics: artwork to be sold, the price of each, and delivery and payment schedules. While the lawyer in me wants to include additional language to protect my client, the art-business side of me understands this may be the best we can get in this circumstance. Pushing for more might jeopardize the deal. If all else fails, you can always put your understanding in a letter or email to the other party. It may be one-sided, but you'll probably hear back if there's any disagreement.

WHAT IS A CONTRACT?

A contract is an agreement between two or more parties that establishes what the parties will or will not do. Usually, parties will negotiate terms that are acceptable to both parties prior to finalizing and signing a written document. Following are some thoughts on getting to that final agreement:

 Unless the contract is presented as a take-it-or-leave-it deal, <u>expect to negotiate</u>. There is no harm in asking for what you want. The worst that can happen is you are told "no."

OFFER AND ACCEPTANCE

An offer and acceptance is the result of a successful negotiation. An offer is a promise to do something at a designated place and/or time in exchange for compensation. An acceptance may be conveyed in words or implied by action. For example, if you offer to pay me to bake a cake, I can either verbally agree or simply show up at the appointed time and place with my perfectly executed confection.

Offer and acceptance need to mirror one another. If I offer to pay you a million dollars to ski down Sunset Boulevard tomorrow, you must accept each of those terms without change in order to form an enforceable agreement. If acceptance is conditional—you agree to accept my offer if I pay twice what I originally offered—so you can pay for the cost of the snow machine, then the conditional acceptance is considered a counteroffer, and there is no deal until both parties are in agreement on the same terms.

AGREEMENT

Once there is an accepted offer, the parties are considered to have achieved mutual assent, or a meeting of the minds. In other words, all parties have the same understanding about the agreement. At this point, it makes sense to draft up a contract reflecting your agreement. This takes you to the next phase of negotiation, where the details are examined.

NEGOTIATION

Establishing ground rules at the beginning of a business relationship can save a lot of pain and expense down the road. This is true regardless of whether or not—and perhaps especially helpful when—you are dealing with someone you consider a friend or loyal advocate. At the same time, exercise caution; don't get too caught up in crafting an airtight deal that squelches the creativity and emotional drive behind the project.

PRACTICAL PLANNING

Whether a contract is on the table or not, one or both parties should write down a list of their most important issues. It is not necessary to reveal your entire list, but choosing the most important items to share can provide a starting place for negotiations. When comparing these lists, where terms don't match up, you know you will need to work together to craft a mutually acceptable document.

Initially, you don't have to put the list in order of importance; just get your concerns down on paper. Being clear on what you want out of the deal is as important as understanding what the other party wants. This way you can start a dialogue focusing on common goals and highlighting any potential conflicts before you get too far down the road.

When you make your list, it is not a complete list of everything that should be in a contract. Following are examples of some of what might be important to each party. You can see the different perspectives and where each scenario could present some negotiation challenges. Use these suggestions as a guide in thinking about your own list. The examples are just a start and are by no means exhaustive.

EXAMPLES IN A GALLERY SETTING

POSSIBLE ARTIST DESIRES

>> Agreement for no more than one year to see how
things go.
>> Commissions must be paid no more than 30 days
following sales.
>> Must have at least one solo show every 12 to 18 months.
>> Gallery must cover all advertising costs, including
color cards.

POSSIBLE GALLERY DESIRES

>> Artist must remain with Gallery for at least one year.
>> Commissions to be paid within 60 days following
payment on sales.
>> Shows to be determined based on quality and quantity of work as determined by the gallery.
>> Gallery responsible for advertising through social
media. Any other advertising to be paid for by Artist.

EXAMPLES IN A PUBLIC ART SETTING

POSSIBLE DEVELOPER CONCERNS

>> Artwork must satisfy official requirements.
>> Budget set at a specific dollar amount.
>> Artwork must be installed no later than a
particular date.
>> Developer and/or eventual owner must be able
to use images of work royalty-free to promote sales
of building units.
>> Artwork must be inexpensive and easy to maintain.

POSSIBLE ARTIST CONCERNS

>> Need a certain amount of time to complete the
project regardless of when contract begins.

» Must be able to use Artist's own subcontractors to fabricate and install work.

» Site must be prepared according to Artist's specifications.

» If construction is delayed, payments are still made on time.

» Budget must be flexible to allow for unexpected costs.

Once you have your list, give some thought to your priorities. This is something to keep to yourself. Where are you willing to be flexible, and what do you consider to be deal breakers? Write this down so you can refer to it when you are feeling pressured or flustered by the negotiating process. This is the time to prioritize those items on your list, or break them into groups such as: "must have," "would really like to have," and maybe even "would like to have but could live without." Remember: identifying priorities is for your own personal reference and reflection. Sharing it would undermine your negotiating position.

EMPATHY

Empathy may actually be the secret ingredient to reaching a mutually acceptable contract or main-taining an existing one. Why do I say this? Because being bogged down in negativity and distrust creates a downward spiral. Both parties lose their ability to work constructively either toward a contract or within an existing contract. Every action of the other party is seen through a negative lens. If at all possible, before things go sour, both parties should try to take a giant step back and do their best to put themselves in the shoes of the other party. If this doesn't help, then it is probably time to terminate the negotiations or

find the best way to end the relationship. On the other hand, <u>exercising a bit of empathy at a crucial moment could turn a negative trajectory around</u>.

Normally, I advise galleries and other representatives or agents that it is bad business to force an artist to remain with a gallery or representative if the relationship has soured. This may be best regardless of what the contract says. It has been my consistent experience that creative people do not perform well when forced to stay in such a relationship. Nor do galleries do their best when there is a strained relationship. However, before pulling the trigger on terminating a representational relationship, the artist should consider what the gallery or other representative has invested into the artist's success. The artist needs to give serious thought as to why a gallery might be reluctant to let the artist walk away from a situation into which a gallery may have poured substantial time and resources. Likewise, the gallery should consider what it is that is making the artist unhappy. Perhaps with a bit of empathy and improved communications, the relationship can be built up again, and if not, it can at least be terminated on a less contentious basis.

A CAUTIONARY FAIRY TALE

<u>LOST IN TRANSLATION</u> Once upon a time there was an art-loving king who offered a talented artist a contract to be a royal artist. Unfortunately, the artist did not understand English well. Needless to say, the artist was excited that a king was interested in her and was eager to enter into the relationship. This would have been the perfect time for her to seek legal advice from the Good Wizard. But the king told her there was no time for consulting and pressured her to sign the agreement right away. So instead, the artist had the kitchen maid help her to translate and interpret the contract.

Well-meaning the kitchen maid may have been. But, there were some tricky aspects to the contract that the kitchen maid didn't understand, so these were not explained before the artist signed it. The most glaring misunderstanding involved the duration of the contract. The clause said that the artist could not travel to another kingdom to show her artwork for two years, but—and this was a big "but" that was never conveyed to the artist—the king had the right to extend the contract for up to three more years. So, what seemed a two-year contract effectively became a five-year contract.

Flash forward two years. The artist wants to move on to be the royal artist in the neighboring queendom. She is unpleasantly surprised when the king refuses to agree to a termination of the relationship and challenges her decision to leave, ultimately threatening her with legal action and beheading if she refuses to continue showing art in the kingdom.

It is only at this point that the artist consults with the Good Wizard, who then explains the king's ability to turn two into five years. "But I didn't understand," cries the artist.

Does the artist have a leg to stand on? If the artist's story of never understanding the terms of the contract is true, there was no meeting of the minds at the initiation of the relationship, and the contract is potentially voidable. If the parties can not settle the matter on their own, they will face the enormous emotional and financial expense of taking a long journey to the top of the enchanted mountain to ask the oracle to sort it out.

For financial and reputation reasons, neither party wants to take this matter to the top of the enchanted mountain. Yet, a mutually acceptable solution is not evident. In the end, they reach a settlement only after many hours of tense negotiations and many sacks of gold are spent. The relationship between the king and the artist, which had been friendly and constructive, is irretrievably damaged. The anxiety and tremendous cost to both parties in this case could have been avoided easily with a thorough review of the contract at the outset and more empathy for one another when conflict arose. Unfortunately, there is no happy ending. Whichever side you sympathize with, this scenario presents a very difficult and delicate problem, but highlights the importance of clear communication when negotiating a contract.

BEWARE THE CONTRACT THAT "MUST BE SIGNED TODAY."
Even after, perhaps reluctantly, deciding that a written
agreement is a good idea, contracts are sometimes
treated as an inconvenience that should be dealt with
quickly, without much thought or understanding. It
is not uncommon for an artist to face impatience and
irritation if he actually reads the contract offered and
downright annoyance if he should go so far as to seek
legal counsel to help translate the often-complicated
or poorly drafted language. It is essential that all
parties be allowed reasonable time to understand
a contract prior to execution.

Thus, when evaluating the approach to take in
committing a relationship to writing, it is important to
strike that delicate balance unique to each situation.
This allows creativity to blossom while protecting both
parties from pitfalls of creative expression. The tone of
the relationship has to be set from the beginning. The
more open that tone is, the more likely the relationship
can be communicative and constructive as opposed to
combative.

CHECKLIST FOR BEST RESULTS:

☐ MAKE SURE YOU UNDERSTAND what you are signing.

☐ ASK FOR WHAT YOU WANT, but

☐ BE EMPATHETIC to the other party's desires.

☐ DON'T SIGN UNTIL YOU'RE READY AND SATISFIED
THAT THIS IS A GOOD DEAL FOR YOU.
However, be prepared to settle on something
less than perfect if it's a deal you really want.

☐ IF SOMEONE IS TRULY UNWILLING TO ENTER INTO
A WRITTEN AGREEMENT, REMEMBER THAT YOU CAN
ALWAYS FOLLOW UP A CONVERSATION WITH A LETTER
CONFIRMING THE POINTS OF YOUR DISCUSSION.
While unilateral, this method can still effectively
flush out miscommunication and provide an
enduring record of at least *your* understanding
of the oral agreement.

KEY POINTS *Short & Sweet*

>> Haste does indeed make waste. Do not sign a document under pressure and without fully understanding its contents.

>> Don't be penny-wise and pound-foolish. It is almost always more cost-efficient to seek professional advice at the beginning of a contractual relationship than when a dispute arises.

>> Don't put off until tomorrow what you can find out today. Agree on the deal before you start the project. Too often people get hours or years down the road on a project before they realize they can't agree on the deal.

Chapter 5

BREAKING IT DOWN

BEING ABLE TO BREAK A CONTRACT DOWN into manageable pieces will keep you from becoming overwhelmed by the whole. While there are no hard-and-fast rules for how to organize a contract, most have a similar structure. Understanding that and knowing your own priorities are both important tools in crafting a solid, workable agreement. In the end, it gives you more confidence when you are handed a contract to evaluate. Second, if you choose to draft your own agreements, it gives you a framework.

FOLLOWING ARE THE BASIC ELEMENTS YOU'LL FIND IN MOST CONTRACTS:

AN EFFECTIVE DATE

The effective date can be the date the contract is signed by both parties, or the contract can specify another effective date in the future or past.

THE PARTIES TO THE CONTRACT

The party commissioning a project may be different from the person you are negotiating with. Thus, it is important to determine who is paying the bills, who is responsible for the contract terms, and who will be the ultimate owner of the work.

So, ask: Is the commissioning or purchasing party an individual? A corporation? The government? A representative of the ultimate consumer? Circumstances can vary dramatically. So don't assume that the person with whom you are negotiating is necessarily the party ultimately responsible for that end of the deal. When an individual enters into an agreement, that person is usually responsible for the obligations of the agree-

ment. If it is a corporation or municipality, things can be murkier.

<u>BOTTOM LINE</u>: Find out where the buck stops! In many cases, having the responsible party be a corporation or municipality could actually cut in your favor. The entity is treated as an individual under the law regardless of how many people are involved in the negotiation.

As a result, the people negotiating on behalf of a company or municipality are not personally responsible for the terms of the agreement. This is often a good thing. It means that terms will not change even when personnel change. Also, liabilities will be borne by the entity—usually a deeper pocket than the individual making the contract.[1] Sometimes, however, corporate entities are specifically used to limit the liability of the individual owners. This may ultimately create a situation that does not benefit you if the entity is not financially stable.

For example, Mr. Art Patron, who is one of your best collectors, is also the owner of a limited liability company, Wealthy Development LLC. As part of his newest downtown loft conversion project, he commissions a sculpture from you. You happily sign an agreement with Wealthy Development LLC.

Suddenly, the loft project goes belly-up due to a declining real estate market and Mr. Art Patron's unwise décor choices (excluding your sculpture, of course). Unfortunately, you were

1. It is always important to read closely the section of the contract that addresses either party's ability to transfer the agreement to another party. An artist is generally selected for a specific style or talent, thus making it a quintessential personal service agreement which no one else can perform. And the artist will almost always be prohibited from transferring her obligations to anyone else. But, preserving the company's or municipality's ability to transfer the agreement to ensure its continuing enforceability is likely a freedom that could be beneficial to both the artist and the commissioning party. This sort of transfer ensures that subsequent owners or administrations will be held to the terms of the original agreement.

never paid. Because your contract is not with Mr. Art Patron individually (who's still wealthy), but his LLC (which is all but broke), you can only go after the LLC. It will be virtually impossible for you to force Mr. Art Patron to pay out of his pocket for your time, effort, and expense, unless you can show that he behaved fraudulently. You may also find yourself waiting in line with a lot of other folks. While misery loves company, without more than just your contract for protection, the more money that remains owed, the less likely you are to ever be paid.

Luckily, there are additional ways to protect yourself. In the above example, one option could be to, with the help of your lawyer, use a traditional construction lien or UCC filings. If the LLC dissolves, you may have other avenues to recover money outside the contract. For instance, depending on your additional filings, bankruptcy rules may give you priority to receive any remaining company assets or insurance money. Another possible protection, though difficult to get, would be to ask for a personal guarantee from the project owner at the outset.

RECITALS

Prior to beginning the terms of the contract, there are often recitals that set out the background leading up to the contract—the story behind the contract. Sometimes, these scene-setting sentences are begun with a "Whereas," which serves to make the tone more formal. This narrative should help put the rest of contract in context.

NATURE OF THE CONTRACT

The contract should contain a clause defining exactly what kind of agreement it is. For instance, is it a commission? A consignment? Employment? A license

or loan? Or something else altogether? However, no matter what the contract says, state and federal rules may change its nature or impose additional requirements.

For instance, commissions for public art projects may be governed by federal, state, or local percent-for-art guidelines that require certain types of construction to allocate a percentage of the construction budget for artwork. In addition, laws or policies may establish how the parties accomplish the project. Laws play an important part in defining the treatment of consignment contracts.

CONSIGNMENT

Entrusting goods to another for the purpose of selling the goods.

Imagine that you are representing an artist whose gallery owner skipped town, leaving everything behind in the locked gallery. Creditors are trying to repossess your artwork to cover the gallery debts. A nightmare! Luckily, the law generally supports the position that because the works were consigned they are not available to the creditors to settle the debts of the gallery owner. Thus, you are entitled to access the closed gallery to recover your works.

THE LESSON: When you consign your work to a gallery, the gallery is responsible for the work while the work is in its possession, but the gallery does not own it—you do until it is sold. However, the sad fact is that galleries can be difficult businesses to maintain. If the gallery closes its doors, creditors may try to seize anything in the gallery to satisfy outstanding debts. And if you don't act quickly, it may be near impossible for you to recover your property. Because you maintain ownership of the artwork, state bankruptcy laws may step in to ensure that, as long as your contract is clearly a consignment arrangement, your work is not taken by the creditors.

EMPLOYMENT STATUS

Another area rife with pitfalls is employment contracts. For instance, while a contract may state that you are an independent contractor, if other factors mean that you meet the standards for being an employee, the state and federal government may require that you be treated as an employee and that taxes are paid as if you were an employee.[2]

Companies are often eager to call someone an independent contractor, as it alleviates their obligations to pay employment tax and benefits. However, simply because the person doing the hiring states that a position is a contract position does not necessarily make it so.[3]

One of the most important consequences of employment status is that it can determine who owns intellectual property created during employment. For more on intellectual property, see page 90. Often, the value of an agreement depends largely on who owns the creative output. As either the creative talent or the hiring party, it is important to understand the ramifications of an employee versus an independent contractor and establish the nature of the employment

INTELLECTUAL PROPERTY

The fruits of your intellectual and creative labors.

2. The IRS states that there is not a clear test to make this determination and that all factors in a situation must be considered. However, they do list three major components to be evaluated in establishing the nature of employment:

>> Behavioral: Does the company control, or have the right to control, what the worker does and how the worker does his or her job.

>> Financial: Are the business aspects of the worker's job controlled by the payer? (These include things like how worker is paid, whether expenses are reimbursed, who provides tools/supplies, etc.)

>> Type of Relationship: Are there written contracts or employee type benefits (i.e., pension plan, insurance, vacation pay, etc.)? Will the relationship continue, and is the work performed a key aspect of the business? For more information, take a look at the article titled, "Independent Contractor or Employee?" located at www.irs.gov.

3. While the IRS test is broad enough in most cases, it makes sense to also consider the specific state laws that might apply. These are generally easily found through an Internet search using the state name paired with "independent contractor versus employee." See, for example, New York's rules at www.labor.state.ny.us or California's rules at www.taxes.ca.gov.

relationship at the inception of the relationship. It all comes down to the definition for <u>Works Made For Hire</u>. This is a complex question sometimes, but generally hinges on whether the author of the work is an employee or an independent contractor.

<u>As a general rule, the employer owns the intellectual rights to an employee's creative works</u>. Thus, it is important for employees to maintain all personal creative projects outside of the work environment and to work on them on personal time and with personal resources.

<u>Independent contractors, on the other hand, own the rights to the work they create for an employer</u>. The only way for the employer to obtain ownership rights is if the work is specially ordered or commissioned for a specific use, as defined by the Copyright Act, and there is a written agreement stating that the work is "a work made for hire."[4] If the employer wants to make sure it owns the work, there should be additional language stating that if the work does not fall within the definition of "work made for hire," the contractor agrees to transfer all right, title, and interest in the work to the employer and will execute all documents necessary to achieve this transfer.

<u>BOTTOM LINE</u>: If you are truly an independent contractor, you do not give up your intellectual property rights unless the contract defines your work as a work made for hire, or you specifically transfer those rights in writing. Anything outside the scope of the agreement

> ### WORKS MADE FOR HIRE
>
> If you are an employee or have signed a contract stating your work is a "work made for hire," your creative efforts within the scope of the project or your employment will belong to your employer and not to you.

4. See Circular 9 published by the Copyright Office and available at www.copyright.gov/circs/. This circular provides helpful information in interpreting §101 of the Copyright Act addressing Work Made For Hire.

remains your intellectual property and may not be used for anything else without your express consent.

SCOPE

What services, locations, obligations, and responsibilities does the contract cover? This should be obvious in the first few paragraphs. The contract should be explicit about what work will be produced and how it may be used, so both parties will understand the purpose of the agreement. Any sloppiness in defining the scope can lead to messy conflicts down the road.

Even assuming a clearly defined scope, often it will change or expand as a project progresses. As the project becomes a reality, issues that were previously not considered become key to its successful completion.

For instance, aesthetic changes may sometimes be made at the discretion of the Artist, though it is unusual that changes affecting the cost of a project may be made without both parties' consent. An agreement should specify what qualifies as a discretionary change that is up to the artist versus what "substantial" or "material" changes warrant approval from the paying party.

The best way to deal with unanticipated scope changes includes two components. First, include a "Changes" provision, which sets out how changes (additions, subtractions, or substitutions) are handled. Second, agree that any expansion of the scope beyond inconsequential changes will require an addendum— or a new and separate agreement.

WHEN GENEROSITY GETS YOU NOWHERE

For years, I have worked with fabricators who provide services to artists but are at the same time creative in their own right. Often, these fabricators do exquisite work but have a difficult time maintaining a healthy business because they are lax about defining the scope of work they agreed to do for artists. This results in fabricators investing far more time, energy, and resources into a project than initially anticipated because of their desire to help each artist realize an aesthetic vision. While admirable, this way of doing business keeps some fabricators in an unstable financial situation and ensures that they are always behind schedule in production. Thus, they create the worst of both worlds: more work than they can handle, with little or no cash flow. This forces them to continue taking on more work in order to improve cash flow but, of course, makes the amount of work overwhelming.

Enter, for example, a very difficult and demanding artist who wants to create a monumental sculpture.

Unfortunately, no written agreement exists. The initial correspondence indicates that the fabricator is to cast pieces from molds provided by the artist, and then the artist will be on site to assist with the finishing and patina process.

But, upon receiving the molds, the foundry sees that they are not well constructed. Nevertheless, the artist insisted that the molds be used to cast the sculptures. Not surprisingly, despite the foundry's extraordinary efforts, the castings are pitted and far from perfect.

When the artist comes to add his "final touches," he is distraught at the finish of the sculptures. He has also brought many additional small items that he wants separately to cast and add to the sculpture. Needless to say, the new items were not included in the foundry's original quote. Furthermore, the other complaints the artist has are not the foundry's fault.

As it is the habit of the foundry to favor clients' happiness over good business practices (granted, not always a bad choice), the foundry tries over the course of months to satisfy the artist. In the end, they expend even more resources trying to satisfy the artist, and he proves impossible to satisfy. To rub salt in the wounds, the artist also refuses to pay. Now what? Who wants to spend more time and money litigating this mess? And what about the client who commissioned the work to begin with?

LESSON: The cost of creating a form contract for the foundry up front, including clear scope and changes provisions, and some basic business practices counseling, would have cost far less in dollars, time, and anxiety.

TIME

Time is almost always crucial. Especially if you are taking time to review a proposed agreement, and possibly negotiate revisions to the contract, you need to understand when the other party expects the work to be finished. Once you understand the time constraints, you can determine the appropriate start and end dates.

All too often, I have worked with parties who, because the artwork is to be part of a larger construction project with a previously established schedule, expect the artist to move forward with the design and even fabrication while negotiations are still underway. Essentially, they expect the artist to make an advance of time and/or materials with the good faith assurance that an agreement will be reached, and eventually payment will be made. Beware! Unless addressed up front, this can be devastating and place the artist in an untenable position.

In order to compensate for any work done in advance, a final agreement may have a retroactive effective date to ensure that you are reimbursed for all time and expenses incurred before the contract was

signed. Another option, when time is of the essence, is to have an interim agreement[5] (in writing, of course) that requires good faith negotiations and establishes a budget from which you are to be paid even if the project does not go forward. With no interim arrangement, it is always possible that the other party will simply walk away without paying a dime. Even if you have a good argument for compensation, you may not be in a realistic financial position to go after it. In any event, I strongly urge you to <u>keep careful records of all investment in a project before and after a final agreement is reached</u>.

TERM AND TERMINATION

Term means how long the contract lasts or what obligations will be met before it ends. The term of a contract may be one year, or it may be the length of time it takes for an artist to craft a particular work. In some situations, time is more important than in others. When it is critical, there will be a clause stating that "time is of the essence." For instance, if there is a dedication, scheduled unveiling, or event tied to your performance, failure to perform on time could not only destroy your working relationship but also damage future business opportunities and create liabilities for you and others. This is especially true when the artwork is part of a larger project, like the construction of a building. Then, it is crucial to know how that component works within the bigger picture. Not only does this make term and timing issues clearer, but you may also be able to head off installation challenges by working with the other parties involved in the overall project.

5. An interim agreement might also be called a Memorandum of Understanding (MOU) or a Letter of Intent (LOI). There! Now you know those fancy terms are simple concepts after all.

For many artists, it is hard to determine exactly how long it will take to create a work. Thus, it is important for both parties to be clear about the possible delays and how to address them. Generally speaking, if the artwork is part of a larger project or exhibition, and other parties' ability to complete their work (be they other artists or a construction crew) depends on timely performance, time will be of the essence, and there will likely be little wiggle room. On the other hand, if the artwork is a stand-alone project with no hard deadlines, the purchasing or commissioning party may have a little more flexibility when it comes to how long it takes. As a rule of thumb, discuss any possible reasons for delay ahead of time.

Either of the parties may wish to terminate the agreement before performance is completed. A contract may allow for termination with or without cause.

TERMINATION FOR CAUSE

Indicates the ability of one party to end the contract when the other party violates, or breaches, the contract and does not correct cause of the breach within a reasonable time. "Cause" can include clear violations, or breaches, of the contract that are not corrected within a reasonable time.

RIGHT TO CURE

In contract law, the seller generally has a limited right to cure, or fix the problem, when the goods or delivery under a contract fail to meet the specified contract terms.

Let's say you are to have an artwork fully fabricated and ready for inspection by the client on June 1. But, when the client visits your studio, he finds to his dismay that the work is only half finished. At this point, if there is a right to cure clause, the client has to give you some additional time to complete the work. If there is no right to cure, or you don't finish the work in the extra time, you will be considered in breach of the contract. The client then may be free to terminate the agreement and seek damages.

In this example, damage may be based on how much money the client loses directly or indirectly:

>> Money the client paid you,

>> Money the client paid directly for materials or other labor connected to the artwork,

>> Cost of getting another artist;

>> Cost of delay in the execution of a larger overall project;

>> Reduced value of a larger project due to the artwork not being included; or

>> Any other damages the client can prove, including costs and attorney fees if specifically allowed in the contract.

If, instead, the breach occurs when a client fails to pay you on schedule, you should make a clear demand for payment in writing and give a deadline. This affords the client a right to cure the failure to pay. If you are still not paid, you may then be free to terminate the contract and seek damages.

In this scenario, direct and indirect damages suffered by the artist may include:

>> Amount of money owed to you;

>> Full value of the contract;

>> Economic harm you suffer in not having the completed project available for others to see;

>> Value of other projects you lost as a result of obligations under this contract; and

>> Costs and attorney fees if specifically allowed in the contract.

TERMINATION WITHOUT CAUSE, OR TERMINATION FOR
CONVENIENCE may also be allowed "without cause,"
but only when clearly spelled out in the contract. Many
commission agreements allow the commissioning party
to terminate at will ("for convenience"). This means for
any reason at all, whether it be budgetary or capricious.
Normally, the terminating party still will be required
to pay at least the cost of labor and materials up to the
point of termination and perhaps even a kill fee, which
could be any amount up to the entire contract value.

> **KILL FEE**
>
> An agreed-upon
> amount that you
> will be paid in
> the event the
> contract is termi-
> nated—or killed—
> without cause or
> for convenience.

Sometimes contracts end despite the best intentions
and efforts of both parties. In uncertain economic
times, the funds designated for an art project can be
redirected or evaporate. This is frustrating and may be
cause to terminate the contract. A carefully prepared
budget can minimize the shock of this. For instance,
try to make sure your actual out-of-pocket costs are
paid before you spend the money and that a percentage
of your fee is included with each installment. This can
prevent your financial ruin if a project falls apart before
completion. Be aware, however, that while perhaps fair
and consistent with the artistic input, it is often a tough
battle to get the artist fee front loaded.

Whatever the reason for termination, pay special
attention to what happens to ownership of the intellec-
tual property upon termination.

DEATH OR INCAPACITY

Finally, the contract should state whether, and by whom, the project may be completed, when termination is due to the death or incapacity of the artist. If appropriate, the work can be completed by the artist's estate or representatives. Otherwise, the commissioning party needs to hire a new artist to complete a replacement project.

KEY POINTS

>> Time is of the essence. It might even say so specifically in your agreement.

>> Knowing the players is key to understanding your contractual relationships. The person you negotiate with may not always be the party signing the contract.

>> The nature of the agreement will define your relationship and whether additional federal, state, or local laws apply.

>> An explicit scope keeps the agreement from growing beyond your initial understanding.

>> The duration and ability to terminate a contract establish clear boundaries for your project.

>> Think of these elements as the preparatory steps in a complex recipe. Getting them clearly established at the outset allows you to focus on the main ingredients you need to create your meal.

Chapter 6

HEART
AND SOUL

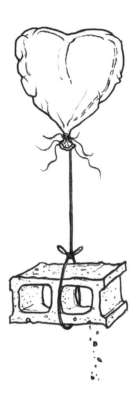

ONCE THE CONTRACT PARAMETERS ARE ESTABLISHED, you can begin to think about the meat (or beans, for you vegetarians) of the agreement.

>> HOW MUCH IS THE BUDGET?
>> WHO GETS PAID WHEN?
>> WHAT DOES EVERYONE EXPECT?
>> WHO OWNS WHAT?

BUDGETING

Your project may be one that calls for you to present a budget as part of the selection or contracting process. Each project is different, so there are no hard-and-fast rules for developing a budget, except this one: If you do not see where you will make money on the project, you need to reconsider. If you're not making money, you better be making something else—like a huge reputation or a donation you need for your taxes this year. In addition to figuring out the cost of creating an artwork, an important part of budgeting is to realistically figure out where you will make your profit, or artist fee. Be honest about this. It's easy to feel excited about a potential project at the beginning, but if you are not able to financially make it worth your while, you will probably quickly find the project to be a mental and financial burden.

Following are some good general, and not complete or exhaustive in any way, questions to get you pointed in the right direction when preparing a budget:

>> Have you realistically considered the hours it will take you to get the project done?
>> Are the materials you propose to use subject to wild market fluctuations? Think copper, gold, and other valuable resources.

» Did you get bids from fabricators or other subcontractors?

» For how long is the bid good?

» Have you calculated in a contingency in case costs change along the way or you need to get some additional help on the project (generally around 10%)?

» Do you know the cost for insuring, transporting, and storing the work?

» Have you figured in the costs of permits, licenses, and any potential sales or use taxes?

» Have you calculated accounting and attorney costs?

» Are you including a realistic amount for yourself at the end of the project?

Being able to accurately budget a project is crucial to being successful in business whether you are a public artist, graphic designer, or an artist engaging in any other commissioned project structure. Not only does the budget establish the way in which money will be spent, but also how you will earn your portion. A well-crafted budget is critical in establishing performance milestones and a payment schedule. Thus, a couple of additional questions to consider:

» How does your budget relate to performance milestones?

» Are you sure you're allocating enough money along the way in your payment schedule to cover the cost of materials, labor, and other out-of-pocket expenses?

» Will your fee be paid at the beginning, throughout, or at the end of the project?

The answers to these questions will vary enormously, depending on the nature of the project and the rela-

tionships involved. Once you have a handle on the budget, you can consider how payment will happen.

PAYMENT

Payment may be structured in a number of ways. There is no "right" way, except to be sure that it makes sense and is appropriate for the work.

EMPLOYEE

If you are an employee, normally you will be paid a salary. In addition, you may be entitled to compensation in the form of commissions, bonuses, and/or benefits. If you receive a salary, make sure you understand when it is to be paid (in advance or for work already completed) and how often (weekly, semi-monthly, monthly). Note that if your employer provides health care, retirement, or other such benefits, you may not see it as cash in your pocket, but it has real value that should not be ignored when evaluating the job opportunity. In the event of termination, you should establish what, if any, severance package applies. Finally, as an employee, you must provide the appropriate tax forms to your employer so that you will receive your W-2 at the end of the year.

CONTRACTOR

As an independent contractor, your fee is normally either payable upon certain milestones or at the end of the project. Alternately or additionally, you may be entitled to a commission if the project is a sales-driven venture. Either way, you will probably need to submit an invoice to get paid.

You should know if you are entitled to compensation if the project is terminated prior to completion. As an independent contractor, it may be a termination or "kill fee." Don't rely on the good will of whoever holds the purse strings—be sure you address questions of premature termination up front.

As an independent contractor you will need to complete tax forms so that your employer can prepare a 1099 at the end of the year.

If you are required to submit an invoice in order to get paid, make sure you understand the form and detail required. Some employers require a specific form invoice. You don't want to find this out only after your request for payment is rejected for the improper format. Always feel free to ask for a sample to make sure that you are complying with all invoicing formalities. Inability to get paid because you haven't filled out the right paperwork can top the list of frustrating situations, but it is not at all unusual, and more often than not, caused by poor administrative processes rather than nefarious intentions.

I was once consulted on a matter, involving multiple parties and a time-sensitive project, where my client, an artist we'll call Vincent, did everything he understood he had to do to receive his initial payment. Yet, despite numerous requests and demands, Vincent wasn't getting paid. Vincent was just about ready to cut off his ear in frustration when, finally, one of the parties informed him that an additional document—waiving liability for any potential subcontractor liability—had to be completed, signed, and submitted before payment would be issued. So, after months and months of struggling to start the project, Vincent submitted this last document and finally received a check.

In addition to being paid for your performance and the costs associated with the work itself, as either an employee or an independent contractor, you may also

be entitled to <u>reimbursement for expenses</u> incurred such as marketing, travel, or other ancillary activities. If expenses are reimbursable, make sure you understand what sorts of expenses are allowed and what sort of proof you have to submit.

Another important area where you should make sure to be financially covered is changes to the nature or scope of the contract. If the employer adds more duties to your job or requests a change to the artwork that results in increasing the project cost—in materials or time—you need to know how you will be compensated.

<u>FUTURE PAYMENTS</u>

Beyond the immediate payment terms of the contract, unless you have relinquished your intellectual property rights (see Work For Hire discussion in Chapter 5), you may be able to negotiate for future royalties or licensing fees. This means you would be entitled to a percentage of sales for all reproductions or derivative uses of your work. The owner of the intellectual property can split that right into as many pieces as desired. So, the right to make lunch boxes can be separated from the right to print t-shirts, postcards, and so on. If you are participating in the profits, it must be clear whether your interest is in the "gross" profits (the total amount of money earned) or "net" profits (the total amount minus certain expenses). Make sure the contract clearly defines which number is used.[1]

1. Those people doing business in California should also be aware of the California Resale Royalty Act—though it is the subject of legal challenge as this book goes to press. This law entitles artists to a 5% royalty for any work sold in California by a dealer or agent at a profit and for more than one thousand dollars (unless the artist first sold the work to a dealer and the sale is between dealers in the subsequent 10 years). When the resale royalty applies, the agent or dealer who sold the work must either locate the artist within 90 days or make the 5% royalty payment to the California Arts Council. The Council will then hold the money while they continue to search for the artist. While the right to this royalty lasts for the life of the artist plus 20 years, the artist has only seven years during which to collect the royalty.

The most important thing to note about net profits is what expenses may be deducted before you get paid. It is entirely conceivable that with a broad definition of deductible expenses there will be no profit—ever (as so many of those in the entertainment world have discovered). A royalty payable on a net number may be completely appropriate—just be sure to examine and understand the method for arriving at that net number.

ACCOUNTING RIGHTS AND STATEMENTS OF INVENTORY

Your contract should clearly establish the accounting procedure to be used if there are future royalty or licensing fees. Contract terms can vary widely, but you may want to insist on receiving a regular statement showing the calculation of your payment. Sometimes, more elaborate accounting rights are allowed. In such cases, you will be entitled to reasonable access to the books. Further, the artist may be able to recover accounting costs if there is a substantial enough discrepancy between what the artist is owed and what the artist was (or was not) paid.

PERFORMANCE

While it is easy to say that each and every clause of a contract is crucial, performance schedule really is close to, if not actually at, the top of the list. It is absolutely essential to have a clear understanding of what a project's milestones are and when they must be completed, if the creative process is to progress in a constructive manner. This schedule may not be always precisely defined. However, timing is imperative, especially in situations where performance

is tied inextricably to the performance of others; for example, when it is part of a larger project. The legal way of saying this is "time is of the essence."

TIME IS OF THE ESSENCE

When this specific language occurs in contracts, it means that on time performance is crucial to the success of a project.

When a contract states that "time is of the essence," it is important to understand why. Perhaps your project constitutes a small portion of a larger project. Then it is necessary to understand the nature of that project. For instance, when I work with clients who are creating work that is part of a larger construction project, we often need to have access to the general contract and performance schedules governing the other contractors and aspects of the construction. If it is not feasible to obtain or review that document, then I will require that the contracting party provide us with any pertinent language (schedules, dispute resolution, invoicing requirements, and indemnity limits, to name a few) and disclaim the rest of the contract as inapplicable to our agreement.

All this is important both for understanding how your piece of the project fits into the larger picture, and in deciding timing for design, fabrication, and installation. It makes no sense to complete and install an artwork without respecting the other construction in the vicinity, because that could pose substantial risk of damage or destruction to your artwork. Furthermore, if your project requires special installation considerations—like walls of a particular strength for heavy artwork or a pedestal for a sculpture—you must address these additional issues before other construction proceeds. Finally, it may be possible to share installation equipment with other contractors on site to cut costs.

As basic as some of these considerations may seem, time and time again I have seen projects move forward without any thought by the owner or general contrac-

tor about the impact the construction will have on the artwork. This may seem to require you, as the artist, to acquire a burdensome amount of information for a relatively small project. However, it is the best way for you to establish yourself as a professional who knows how to work in a construction setting. This will serve you well if you wish to participate in public or private art projects.

The timing of a project is also important from the artist's standpoint because what was initially established as an "on-time delivery" may not necessarily benefit you or the artwork, depending on the bigger picture. For instance, if you have not been in communication with the client or the general contractor on a project, you may not know that construction (as it so often does) is running behind schedule. This means that even if you complete and deliver the work to the site as agreed, you might not be able to install it. The cascading effects can include additional costs to you in rescheduling installation, as well as issues involved in storing the work while you wait for the other elements to be completed, and the question of who is to be responsible for the work prior to installation. These issues become more complicated if the work is not as easily stored or as resilient to storage conditions as drywall or concrete might be.

Thus, in addition to establishing a clear schedule for performance, it is necessary to consider the potential consequences of what others are doing. To head off problems from the outset, establish clear and regular communications about performance schedules and contingency plans in the event that completion dates change.

<u>Finally, and by no means insignificant</u>, is the relationship between performance and payment. More often than not, milestones are involved, payments will be tied to them. Performance schedule may also be crucial in determining when royalties or commissions are due. Failure to pay on time is one of the biggest areas for dissatisfaction and dispute.

DUTIES, REPRESENTATIONS, & WARRANTIES

Duties, representations, and warranties in an agreement can range from the mundane statements that establish the individual or corporate status of a party to information that is crucial to the maintenance of the artwork.

<u>DUTIES</u> are obligations that each party pledges to fulfill.
<u>REPRESENTATIONS</u> are facts that each party states to be true.
<u>WARRANTIES</u> are guarantees a party makes as to the standards, quality, and durability of products and services provided pursuant to the contract.

Following are some of the more common duties, representations, and warranties:

» <u>Information regarding nature of each party</u>. In other words, are you and the other party entering into the agreement as individuals, or as representatives of another entity such as a corporation, trust, or partnership? This is important so that you know exactly with whom you are contracting. Sometimes, the person you've been discussing your arrangement or project with is not the ultimate party you will have

the deal with. Also, if you have incorporated your business, determine if it is better from a liability or tax standpoint to have contracts with your company rather than with you as an individual. In such instances, seeking legal or accounting advice may be advisable.

» There are no other agreements or circumstances that will cause a conflict or other difficulty in carrying out the terms of the contract. Especially important if you recently left a creative job with a non-compete agreement or have multiple galleries representing your work.

» Physical necessities for actually displaying or installing the artwork. This includes information and expectations about the proposed installation site, durability of materials, or construction of the artwork.

» The nature and quality of what is to be delivered. This may include not only the quality of fabrication but also the condition in which artwork is delivered. For example, some consignment agreements require flat work to be framed, sculptural work to include pedestals, and work to be otherwise in a condition to be immediately displayed without further effort or expense by the gallery. If the artwork is a permanent installation, you should consider the qualities of each component that may cause problems down the line. Glass cracks, electrical devices short out, and water seeps and intrudes.

Equally important are the attributes of the artwork's location. For instance, it is important to take into consideration whether a site close to the ocean will expose an artwork to salt air, which is

much more corrosive than non-salt air. Environmental aspects must not be ignored when selecting materials for fabrication. Even so, you might find yourself being asked to warrant the artwork against salt air damage.

Give careful consideration whether you want to warrant against damage that these inherent traits could cause, or to exclude responsibility. If you wish to exclude liability here, you will likely need written permission from the client purchasing the work. A warranty period is usually one or two years but may be as many as 10 years, depending on the project. You may be able to negotiate a shorter period if you do not make exclusions from the warranty, or you may need to agree to a longer period if you request specific exclusions.

» The work created or provided for in the agreement is original. It does not infringe on anyone else's intellectual property. This is particularly important for artists who integrate others' works into their own. While the transformative use of other materials might exempt the artist from ultimate liability (i.e., the artist uses another's work in a way that results in a new and unique work), if there are any claims made by third parties, the artist will still be responsible for the cost of defending such claims. Therefore, to avoid any possibility of conflict, the best policy is to create completely original work or to use others' work only if it is in the public domain. It can get complicated for those artists whose work is all about appropriation; but regardless of the conceptual issues appropriation raises, the artist will likely be responsible for footing the bill for any controversy.

» <u>Ownership and reliability of other intellectual property integrated into the project</u>. This warranty becomes an issue especially when an artist is using patented technology to bring motion or other functions to an artwork, but could apply to any components that are not actually fabricated under the artist's control. A patent holder will likely not object to, and may indeed be flattered by, the use of his technology in a project. However, the artist can only transfer ownership of the integrated component itself, including any underlying warranties that come with it, but cannot transfer the patent or any other intellectual property associated with the component.

For instance, if an artist plans to integrate solar panels into an artwork, she can guarantee the artwork itself for two years, but the solar components may only come with a one-year warranty from the manufacturer. The artist should not give the client more of a warranty on the solar panels than she has herself. So the contract can state that the two-year warranty applies only to the artist's work, and she can pass along the manufacturer's one-year warranty for the solar panels.

» <u>Ongoing duties</u>: If the contract pertains to a relationship that you expect to be ongoing (as opposed to a one-time sale), it should set out continuing duties that each party has to the other:

 o Providing updated contact information, resume, and promotional material to be used for marketing purposes;

 o Cost-sharing for marketing expenses, such as postcards promoting a gallery show or advertisements placed in appropriate publications;

 o Frequency of gallery shows—solo or otherwise;

 o General communication duties regarding scheduling that may affect the execution of the

contract—for example, construction delays that alter the completion requirements.

>> <u>Maintenance of the work and procedures for any necessary repairs</u>. This is another ongoing responsibility that will endure past the term of the contract and may include cleaning and repairing the work as well as the ability—or perhaps the inability—of the owner to move, alter, or destroy the work.

<u>MAINTENANCE</u>

The steps and procedures necessary to ensure that the artwork remains worthy of display.

MAINTENANCE

Generally, the artist will create a written manual specifying the requirements for maintenance. The contract should also state who is responsible for funding and overseeing the maintenance.

Sometimes, even with the best of intentions, the maintenance of an artwork may not be realized without a clear contractual obligation. Ideally, when public art is commissioned by a private developer, a fund will be established at the beginning for maintenance. For instance, a plan to use homeowner fees from the residential development benefiting from a public art installation to pay for the maintenance of the work makes a lot of sense. Unfortunately, if the homeowners hate the artwork and reject the notion that they should maintain it, there is a serious problem. One possibility is for the developer to establish a fund at the beginning that covers the cost of maintenance for the life of the work. Another option might be to gift the work to the city and integrate it into the city's maintenance program. Otherwise, the artist may be stuck with the complicated and potentially expensive option of suing the homeowners' associations and the developer to ensure appropriate care of the artwork.

Such solutions are not always possible—especially in times of tightened budgets and the elimination of many

public art programs. Because maintenance is crucial to the life of public art, if there is not a capable and/or well-funded entity willing to commit to this obligation, other possibilities must be considered. Some artists are starting to build into the project budget an amount dedicated to long-term maintenance. The ability to do this may depend on specific ordinance requirements or the flexibility of the commissioning party, and it may not ultimately be enough money, but in any event, it is a good strategy to keep in mind.

REPAIRS

The contract should include a clear procedure for how repairs are handled if there is damage to the artwork—whether it is consigned to a gallery or work purchased for permanent installation. While the party in possession of the work will generally be responsible (assuming that it was delivered in the agreed-upon condition), it is to everyone's advantage that the artist be notified of any damage. The artist is likely to be the best person to perform any repair work or recommend someone who can.

RELOCATION OR REMOVAL

The purchaser may decide at some point that he wishes to move or remove an installed artwork. Unless the artist waived his rights conferred under the Visual Artists Rights Act (VARA), the purchaser must obtain the artist's permission to alter or destroy the artwork. VARA is part of the federal Copyright Act.[2] VARA precludes the destruction, alteration, or mutilation of works of recognized stature. Remedies for VARA violations include the artist's right to prevent destruc-

VARA

Implemented in 1990, VARA is the closest thing the U.S. has to moral rights for artists. Though not as broad as European moral rights, it's definitely better than nothing!

2. 17 U.S.C. §106A.

tion of the work, remove her name from the work, and possibly monetary damages.

In addition to VARA, there are several states that also have addressed moral rights of artists.[3] VARA preempts state laws that are less restrictive, but state laws may provide broader protection to artists.

VARA is not the clearest of laws. There has been much discussion in and out of the courtroom as to its exact meaning. So, it is often in both parties' interests to substitute clear language in a contract to address their specific situation. However, in order to unambiguously supersede VARA or applicable state laws, the rights these laws grant must be waived. Waiving your rights can be very scary and should be. That is why any VARA or other waiver must be followed by a clear and fair replacement for the waived rights.

If the contract is properly drafted, you can actually gain more than you lose with a waiver of VARA rights and the substitution of well-crafted replacement language. Generally acceptable replacement rights might include clauses like these:

>> If the work is to be moved, it may only be done pursuant to particular parameters. For instance, a sculptural display made up of several pieces must be displayed together in the new location as originally intended—the work cannot be split up into its component parts and displayed separately.

>> If the work is to be permanently removed, the artist shall be given the opportunity to retrieve it. Reasonable arrangements to address the logistics and cost can be specifically set out or left for future negotiation, depending on circumstances.

3. See, for example, the California Art Preservation Act (1979), The New York Artists Authorship Rights Act (1983), the Massachusetts Moral Rights Statute (1984), the Maine Moral Rights Statute (1985).

» If at any point during the life of the work, the purchaser does something to it that the artist considers undesirable, the artist may reserve the right to remove her name from the work.

When there are competing interests with regard to VARA rights, an honest discussion often yields an acceptable compromise. Such a compromise can provide the flexibility an owner desires as to, for example, future treatment of the work, without requiring that the artist give up all of his VARA rights.

Take, for instance, an artist who creates a series of works, consisting of several sculptural pieces meant to be viewed together. The owner wants her to waive all of her VARA rights so there are no restrictions on the future ability to relocate the works. She is not opposed to the possibility of relocating the work but wants the pieces to be displayed together and in the same configuration to preserve their integrity. The owner agrees to make reasonable efforts to accomplish this.

While certainly not a guarantee that future conflicts will not arise, this goes a long way to at least express in writing the parties' understanding and intentions regarding the long-term treatment of the artwork.

VARA may also apply to works sold through a gallery, but it would be unusual to address the artist's VARA rights in the consignment agreement. However, a gallery may include information on its sales invoice regarding the artist's VARA rights along with any copyright information to make sure that collectors are adequately informed.

NON-COMPETE & NON-SOLICITATION

NON-COMPETE

Restricts your ability to take a competing job for some specified period of time.

NON-COMPETE LANGUAGE restricts the scope and nature of other projects to which a party can commit during or after the term of the contract. If an artist is hired to provide animation services to a production company, the company may try to restrict the artist from providing similar work to other production companies for the term of the agreement and for some time after.

Many states restrict non-competes. In California, for example, non-competes for employees are generally forbidden. So, if you see a non-compete provision, you should seek counsel to determine the exact regulations that apply in your state.

NON-SOLICITATION

Prohibits you from making use of certain professional contacts after leaving a job. Can pertain to efforts to hire employees from your former company or working with your former company's service providers.

NON-SOLICITATION LANGUAGE usually means one party trying to restrain the other party from poaching talent or accounts once the work described in the contract is finished. While this seems like a reasonable expectation, the situation may quickly become fuzzy, especially for freelancers. It is often during such employment that one makes useful contacts and connections. The rule of thumb here is to tread carefully and be sensitive.

CHANGES & AMENDMENTS

CHANGES OR AMENDMENTS TO THE CONTRACT. When drafting contracts, the goal is to anticipate every possible future situation. Unfortunately, no one has developed a way to do this. Thus, it is imperative that there be a clear and effective way to amend a contract as necessary. The clearest way is generally to require that any material changes be in writing and

signed by both parties. This will offer the best hope of minimizing confusion and conflict.

Some contracts, especially when the artwork is commissioned in conjunction with a larger construction project, will set out a more complex and formal procedure for requesting and approving change orders for material or significant changes to the project. These can involve anything from a change in schedule to a change in the scope of the work, all the way down to changes in the smallest details affecting creation, fabrication, delivery, or installation.

CHANGE ORDERS

Written documentation required to consider and approve a requested change to the project.

In either scenario, the question often boils down to determining what a material change or significant change is.

For example, if a glass artist is to create a piece with specific colors, and one of the colors is no longer available, the artist may be allowed to use her best judgment to select a replacement color without consulting the commissioning party. On the other hand, the terms of the contract may view this as a material change that requires the new color to be proposed and resubmitted for approval. This might be specifically defined in the contract, but how it is interpreted depends largely on the level of control a commissioning party wishes to exert and how much artistic latitude an artist feels she should have. Obviously, the commissioning party wants to end up with an artwork that is what was initially anticipated in the commissioning process. The artist needs to be able to work with the least amount of restriction on her artistic sense in order to create something that truly expresses her vision.

MATERIAL OR SIGNIFICANT CHANGE

"Material" or "Significant" refers to the importance of the change. What is considered to be a major—or "material"— change can be precisely defined in the contract.

It is often helpful for everyone to discuss these potentially competing interests at the outset of negotiations, and to open the lines of communication about aesthetic expectation and artistic vision. If the

artist demonstrates a clear understanding of what is expected, it is often easier for the commissioning party to trust that the artist's choices will result in a work that pleases everyone.

LIABILITY

What if there's a problem? Who's liable? There are three main sections in almost every contract where answers to these questions may be found:

1. INDEMNIFICATION
2. RISK OF LOSS
3. INSURANCE

Even slight variations in the language of these sections can alter who is ultimately responsible.

INDEMNIFICATION CLAUSE

If there are injuries, damages, and/or lawsuits, an indemnity clause will establish who pays the costs and any judgment, if there is one.

> For example, a developer commissions an artist to install a sculpture on a foundation engineered by the developer. The foundation fails, the sculpture falls over and injures a passerby, who sues the artist and the developer. If the developer agreed in the initial commission agreement to indemnify the artist in the event of liability caused by the developer's negligence, liability for the injury will ultimately be the developer's responsibility.

Reading the indemnification language is very important because sometimes the scope of coverage is broad, while other times it is much narrower. Further, sometimes it's a one-way street, while other times the responsibility goes both ways. A mutual

indemnification provision is obviously the most fair. However, it is not always easy or possible to attain.

The two most common stumbling blocks are:

1. EXTREME POWER DIFFERENTIAL
 If a commission is highly desirable or there are many artists able and willing to complete it, the commissioning body has a lot of negotiating power and may refuse mutual indemnification (among other things).

2. BUREAUCRACY
 The indemnification language is dictated by another body (like a city council) and cannot easily be revised for individual contracts.

Another consideration is how realistic indemnification actually is. In order to be meaningful, the indemnifier's pockets must be deep enough or there has to be an insurance policy. It should come as no surprise that, with notable exceptions, artists tend not to have deep pockets. Unfortunately, insurance may be too expensive, or the insurance underwriters might not be willing to write the policy. Taking on more responsibility for indemnification than you can realistically cover is a dangerous game.

You should also consider the project's potential for creating liability. A heavy object suspended over a crowded public area is probably going to carry more potentially serious consequences than soft sculpture on the wall of a rarely traveled corridor.

Some agreements include more complex indemnification language. These variations tend to add more requirements, such as project-specific ones. However, the concept remains the same. It is up to the contract-

UNILATERAL

Artist agrees to indemnify and hold harmless Owner, Owner's successors and assigns from any claim or suit arising out of a breach by Artist of any contractual obligations set forth in this Agreement.

NOTE: The lack of responsibility from Owner to Artist.

WHAT DOES IT MEAN?

Artist is responsible to make Owner whole in the event that there is liability resulting from Artist's actions. Thus, Owner is definitely covered. Artist, on the other hand, is not necessarily covered for liability resulting from Owner's actions. (It is still possible that Owner's insurance would cover damages if, for example, Owner's construction equipment damages Artist's work during installation, or if Owner's gallery burns down. However, with a unilateral indemnification clause, the indemnification responsibilities are definitely lopsided.)

IS IT FOR ME? / WHAT SHOULD I DO?

If you're the party who's covered, yes, you're happy. For the party who's potentially responsible, not so much.

Depending on your bargaining position, there may not be much you can do. However, it never hurts to ask for a mutual provision to be added. The worst they can say is no.

Public entities tend to be especially unwilling to make this sort of change because any substantive changes, especially regarding liability matters, have to go through a complex bureaucratic process.

If you are unable to revise the indemnification provision, you need to assess whether the project is likely to result in liability for you and whether this is a deal-breaker or not. This is where the advice of a lawyer may be helpful to guide you through the specifics of your situation.

MUTUAL

Artist agrees to indemnify and hold harmless Owner, Owner's successors and assigns from any claim or suit arising out of a breach by Artist of any contractual obligations set forth in this Agreement. Owner agrees to indemnify and hold harmless Artist, Artist's successors and assigns from any claim or suit arising or resulting from the breach by Owner or its agents of any contractual obligations set forth in this Agreement.

NOTE: The mirrored language so that each party is responsible to the other.

WHAT DOES IT MEAN?

Responsibility goes both ways.

As long as the language is truly reciprocal, both parties take equal responsibility for their respective behaviors and actions.

IS IT FOR ME? / WHAT SHOULD I DO?

Most likely, yes! This is a fair way to go as long as the scope of the indemnification language is reasonable.

As long as the scope of the indemnification language is reasonable, this provision should not be an issue, and you need to move on to reviewing the rest of the contract.

You should pay attention to the scope of the indemnification. For instance, does it cover anything that can result in liability? Or does it cover just willful or negligent actions that result in liability?

ing parties to scrutinize the specifics. Some variations you might see include:

> Further detail about circumstances and procedures for settling claims.
> Specific concerns about intellectual property.
> Stipulations as to who pays and who makes decisions about legal counsel such as selection and scope of representation.
> Remedies available.

RISK OF LOSS

He who bears the responsibility for any damage or loss that occurs to the artwork bears the risk of loss. Risk-of-loss issues are often lost in the shuffle or conflated with other concepts like insurance, final acceptance, and transfer of title. It is imperative that there be a clear risk-of-loss policy so that everyone knows exactly what he or she is responsible for. So, while the artist generally bears the risk of loss for a work until the work is delivered to the gallery or ultimate purchaser, this is not always true. Sometimes a contract will call for delivery of artwork to a site where it will sit until the work is formally accepted. Then, the artist remains responsible until the acceptance. This is reasonable as long as the accepting party agrees to cover any loss from damage that is out of the artist's control. In any case, whoever bears the risk of loss should maintain insurance that covers the work until the risk transfers to the other party.

If the artwork is delivered by a third party, responsibility for loss during transportation should be stated as well. The responsible party would be wise to have insurance during transport.

One of the major pitfalls in drafting risk-of-loss language is that it is often combined with transfer-of-

title language. This is because many people assume that responsibility for damage to the artwork should not shift from the artist to the owner until title is transferred. However, risk of loss should be based on who has physical control over the artwork. While transfer of title is more appropriately linked to final payment (which could occur days or weeks after delivery or installation of the artwork).

The main considerations for risk of loss are:

>> Who has control of the work?

>> Who is in the best position to protect the work and ensure that no damage or loss occurs?

The answers tend to be situation-specific and go hand-in-hand with storage issues when a project is delayed and artwork must be stored until the site is ready. Thus, if the commissioned work is small and easy to store and transport, it may be in the artist's best interest to hang on to the work, and the risk of loss, until the site is ready for the work to be installed.

When a work is not easily stored by the artist, it makes sense for the commissioning party to store it if there is an appropriate and safe place on the construction site. Although the ownership of the work will not transfer until the artist receives final payment, the commissioning party now has control of the work, so it is in the best position to safeguard it, and thus bears the risk of loss until the site is ready for installation.

 If neither party is able to store the work until the site is ready, there should be a provision for storage in a mutually acceptable location with the responsibility for risk of loss and cost clearly spelled out. Don't forget to consider creative solutions that might be more cost-efficient and less trouble. For

example, depending on the nature of the artwork, the fabricator may be able to provide storage.

<u>INSURANCE</u>

Obtaining insurance will, in most cases, be a relatively simple matter of providing the appropriate information to your insurance carrier. Many contracts specify in detail the nature and amount of required insurance. The types of insurance may range from general liability, for anything arising out of the fabrication and installation, to specifics for car insurance.

Other types of insurance may be requested, but more often than not are either unobtainable or inappropriate for artist contracts. While it is often requested, professional liability insurance (errors and omissions coverage available to licensed professionals such as architects and engineers) is simply not available to artists. This is particularly true in design-only projects. The best way for an artist to be sure there is some protection is to make sure an architect or engineer signs off on the artwork so it is covered by their professional liability insurance. In addition, it may be necessary to obtain waivers for those insurance requirements that might be standard for other contractors (such as worker's compensation) but not appropriate for an individual artist's project.

TITLE

Ultimately, pretty much any art-related agreement results in the transfer of some form of property right, be it the <u>Title</u>, the Intellectual Property created when the work of art is fabricated, or some combination of the two. These ownership issues trigger both short-term

TITLE
Ownership of the physical artwork.

and long-term effects and thus should be addressed carefully and fully.

Understanding the distinction between physical and intellectual property is the key to clarifying ownership issues as well as determining the timing and manner of the actual transfer of rights within the contract.

TRANSFER OF TITLE

Title is the official ownership of the physical piece (the artwork itself). Transfer of title should never occur prior to final payment unless there are technical or tax issues. If transfer of title occurs earlier, the artist has no way to pressure the other party in the event of non-payment.

In the case of commissioned work, the work will likely be installed prior to a final acceptance and the processing of a final payment. Without the incentive of getting the transfer of title (which may impact the ability of the owner to obtain final certificates of occupancy or approval from an arts commission), final payment may be dramatically slowed or even—believe it or not—overlooked altogether.

When work is sold through a gallery, transfer of title generally comes with delivery, which should only take place after full payment. Making payments over time to buy artwork is a common practice no matter how wealthy the purchaser. This practice has allowed countless artists to sell—and collectors to acquire—works that otherwise would have gone unsold. Yet, the works should never be delivered to the owner until all payments have been made.

However, if a gallery allows a potential purchaser to take the work home "on approval," to essentially try it out before she commits, the gallery should always take a deposit. Ideally, it would be the full cost of the work but certainly no less than the value of the artist's

commission. The gallery could also take a credit card number, after verifying that it is valid and could be charged upon purchase, or if the work is not returned within the agreed-upon approval time.

In addition to establishing how ownership of the artwork itself is to be transferred, a contract should always establish physical ownership of documents and other materials generated in the course of performing the contract. This could apply to design concepts for installation works, drawings, maquettes (models of the proposed work), and any other creative documentation. In some cases, especially when public funds pay for an art project, the purchaser may want to display the underlying work for public relations purposes. Again, it must always be clear that, unless otherwise agreed, the copyright remains with the artist.

INTELLECTUAL PROPERTY

Intellectual Property covers a range of areas. Visual artists will generally be concerned with copyright as opposed to trademark or patent. If the contract is for graphic design services, trademark issues may come into play. Nevertheless, it is useful to have a basic understanding of the distinctions among the three categories of intellectual property.

> **INTELLECTUAL PROPERTY**
> Rights that are protected by Patent, Trademark and Copyright laws.

1. PATENTS
Patents are issued for inventions that are unique and non-obvious. The Patent and Trademark Office (the "PTO") grants a property right to the inventor for a limited period of time. The website for the PTO can be found at www.uspto.gov.

The term of a new patent is 20 years from the date on which the application for the patent was filed in the United States or, in special cases, from the date an earlier related application was filed, as long as you stay current on maintenance fees. U.S. patent grants are effective only within the U.S., U.S. territories, and U.S. possessions.

The right conferred by the patent grant is, in the language of the statute and of the grant itself, "the right to exclude others from making, using, offering for sale, or selling" the invention in the United States or "importing" the invention into the United States. It is important to note that what is granted is not the right to make, use, offer for sale, sell, or import the invention, but the right to exclude others from doing any of that.

2. TRADEMARKS AND SERVICEMARKS

Trademarks and Servicemarks are also administered by the PTO. A trademark or servicemark is a word, name, symbol, or device, used in connection with goods or services to indicate the source of the goods or services and to distinguish them from the goods or services of others. The terms "trademark" and "mark" are commonly used to refer to both trademarks and servicemarks.

Trademark rights may be used to prevent others from using a confusingly similar mark but not to prevent others from making the same goods or from selling the same goods or services under a clearly different mark. After registration, the appropriate affidavits are filed with the PTO; trademark registrations last for 10 years and can be renewed for additional 10-year periods.

BTW
The ® symbol can only be used if you have a trademark registered with the PTO. On the other hand, ™ can be used any time you want to assert a trademark interest but have not registered the mark.

3. COPYRIGHT

Many long books have been written and will continue to be written on copyright. It is an extremely complex area of the law. However, for our purposes, just keep in mind a couple of especially important tidbits.

Copyright ownership in a creative work exists and is owned by the author as soon as the work is "fixed in a tangible medium of expression." This is a phrase that has had to be flexible as advancements in technology continuously provide new and previously unimaginable ways in which to create and fix creative expressions. Basically, any creative expression in a physical or technological format viewable or usable by others will be considered "fixed in a tangible medium." So even if the work is not registered with the Library of Congress, copyright exists and belongs to the artist.

Works that do not contain original, creative expression (like recipes or game instructions, which are limited in how they can be conveyed) are not protectable by copyright. The same goes for ideas and concepts. Thus, your secret chili recipe may not be copyrighted—best to just keep it locked in your secret recipe file, guarded as a trade secret. You could, however, gain some protection by publishing a cookbook and obtaining a copyright for the completed work and original elements other than the recipes. Likewise, your idea for iron-on pockets will not be protectable, but any designs you draw to put on the pockets are. And if you invent a new type of iron-on glue, you may want to investigate patent protection for your original idea, but don't submit the formula for copyright protection.

Registration of Copyright

Even if you hold the copyright to your work, it needs to be registered with the Library of Congress in order to

> **BTW**
> The past tense of "copyright," or its use as an adjective, is not "copywritten," it is "copyrighted." Now you can really sound like you know what you're talking about.

exercise any of the remedies of copyright law. For more information about registering copyrights, the Copyright Office provides an excellent web page at www.copyright.gov.

Duration of Copyright

Copyright for works created by individuals lasts for the life of the author plus seventy years, except for those rights conferred by the Visual Artists Rights Act which only last for the life of the author. (See page 78.)

Transfer and License of Copyright

The copyright of an artwork remains with the artist even after an artwork is sold to a collector or permanently installed at a site, unless the work qualifies as work for hire (see Chapter 5). The only way to transfer the copyright is in a writing signed by the artist. So, although the collector or purchaser has bought the artwork, the ability to make derivative works (such as photos, postcards, t-shirts, and calendars or similar works in other locations) or license the work for use by third parties (such as using the artwork in a commercial or film production) stays with the artist unless another agreement is clearly set out in the contract.

In the consignment context, it is important for the gallery to acknowledge that it is only selling the artwork and not the underlying copyrights as well. The best situation is that the gallery not only acknowledges this in the consignment agreement, but also promises to pass this fact along to its collectors. Many galleries are reluctant to do this because they feel that it may discourage sales. However, to avoid confusion down the line, some galleries include boilerplate on their sales agreements that alert collectors to these copyright restrictions.

In permanent installations, a reasonable compromise may allow the purchaser to use images of the work for noncommercial purposes (like educational or public outreach materials), limited commercial purposes (like marketing the condominium or commercial development where the work is), or any other clearly listed uses contemplated by the purchaser. Any other uses must be separately negotiated as they arise.

FAIR USE

Ah, fair use. This is a complicated question that often gets thrown around in a desperate attempt to justify copyright infringement. <u>Fair use does, in fact, allow some types of copyright infringement, but only when it has been shown to be reasonable</u>. The topic of fair use alone could, and does, fill many books. Rather than venturing too far into this behemoth, remembering a few basic facts will give you a rough grasp of fair use.

Fair use is a defense that is raised when one has already been accused of copyright infringement. Therefore, do not think of it as something that will protect you from being sued. Nothing will protect you from being sued. You may have a great defense, and the other side might be completely crazy, but there are no laws against filing stupid lawsuits.

Fair use generally protects the use of copyrighted material for criticism, comment, research, teaching, scholarship, or news reporting.

The factors that the court will consider when determining whether fair use is an appropriate defense were codified in the 1976 Copyright Act. They include, but are not limited to, the following:

>> The purpose and character of the use, including whether that use is of a commercial nature or is for nonprofit educational purposes;

>> The nature of the copyrighted work;

>> The amount and the substantiality of the portion used in relation to the work as a whole; and

>> The effect of the use on the potential market for, or value of, the copyrighted work.

The four factors diminish in importance if the new work is transformative in nature. That is, does the new work present an expression that is different enough in character from the original work that it becomes something worthy of separate copyright protection? Lately, the courts seem to be inclined to find fair use applies any time they agree that an artwork is transformative. This will be a very interesting area to watch as the rule of law continues to evolve.

KEY POINTS

At least retain these:

Payment

» Understand what you need to do in order to receive payment in a timely manner.

» Is payment outlined in an agreement the only way for you to make money, or are there other opportunities to receive royalties, licensing fees, or other income?

Performance

» Establishing and adhering to a performance schedule is crucial to a smooth operation.

» Discussing anticipated deviations from the performance schedule as far in advance as possible is the best way to craft solutions and avoid conflict.

Duties, Representations, and Warranties

» Warranties should be reasonable and specific to the particular nature of each project.

Maintenance

» Proper and ongoing maintenance of an artwork is crucial to protecting everyone's investment and avoiding conflict down the road.

» It may be fine to substitute other promises in place of waived moral rights, as long as the substituted language still protects the artist's right to attribution and prohibits the removal or destruction of the work without proper notice to the artist, including an opportunity to participate in such decisions.

Liability

» Establishing and understanding the procedures for executing and revising terms in the agreement will give everyone the most effective tools for avoiding technical, logistic, and emotional breakdowns.

» Risk-of-loss transfers with control of the artwork.

Title

» Title transfers only with complete payment for the artwork.

Intellectual Property

» Copyright exists as soon as a work is fixed in a tangible medium. However, registration of copyright with the Library of Congress is crucial in order to protect the copyright within the legal system.

» Copyright remains with the artist unless transferred in a signed agreement.

» Copyright generally lasts for the life of the author plus seventy years.

Fair Use

» Fair use is a defense that allows certain infringements and transformative works.

BOILERPLATE & FINALIZING THE CONTRACT

EVEN IF THE FIRST TWO PARTS of your contract
were brief and easy to understand, you may find
the traditional boilerplate language at the end less
readable. Because this language is relatively stan-
dard and tends to be cut and pasted from document
to document, it often seems less specific to the
contract and disjointed. But, some of the most
crucial points for interpreting the contract in
the event of dispute are contained in this section.
So open your eyes and keep up the careful reading!
With the following explanations, you will be able to
decipher and quickly evaluate the fine print.

FORCE MAJEURE

Force Majeure refers to circumstances creating delays
or making performance of the agreement impossible.
Generally, this clause will allow for modification of the
performance schedule or, in the worst case, termina-
tion of the contract. Force Majeure may include one or
more of the following:
 » Natural disasters like tornadoes, floods, earth-
 quakes, or volcanoes;
 » Human-generated events like wars, civil unrest,
 or strikes;
 » Death of either party or someone crucial to the
 performance of the agreement; and
 » Bankruptcy of either party.

SEVERABILITY

If any portion of the agreement becomes unenforce-
able, the rest of the agreement continues to be valid
and enforceable.

For example, you are hired to create a Styrofoam
sculpture, and before you can fabricate it, the local
municipality commissioning the work passes an ordi-
nance outlawing Styrofoam. You still may be required
to fabricate a sculpture and adhere to the terms of the
contract using a material other than Styrofoam.

GOVERNING LAW AND VENUE

This clause establishes in which state and county
disputes will be handled and what state's or country's
laws will apply. This can be important if you live in
New York and must travel to California or China to
resolve a dispute. Further, even if you agree to go to
California, the contract may call for the laws of anoth-
er state or country to apply. While unlikely, and cer-
tainly difficult to execute, this clause might require that
disputes be resolved in Oregon by applying the laws of
France. More likely, the location of the party offering
the contract will determine the place and rule of law.

BOTTOM LINE: Pay attention to this clause. Otherwise,
you may spend a lot of time and money traveling—
and it won't be for a vacation!

INTEGRATION

This clause may also be titled "Entire Agreement," which actually tells you its purpose. An integration clause establishes that the written agreement you are signing is the entire agreement and that all previously written or oral agreements do not apply. This is vital if you are relying on promises made on the side that change crucial portions of the written agreement.

For example, if you sign an agreement with an integration clause, and it calls for you to be paid $10,000, it would be foolish to rely on a pat on the back and an oral promise that you will actually be paid $20,000.

DISPUTE RESOLUTION

Sometimes there is no dispute resolution provision beyond a simple requirement that both parties make a good faith attempt to discuss and resolve any conflicts before rushing to file a lawsuit. Although not offering much guidance, this is often the best way to resolve disputes regardless of the situation. Any of the other solutions often involve substantial cost as well as a tremendous commitment of time and emotion. In most cases, engaging in an honest discussion of the issues (or hiring someone who can do that for you if the situation is too emotional already) will more quickly and efficiently yield a practical solution.

If there is a dispute resolution clause, it may provide another way to deal with disputes beyond simply filing a lawsuit. For instance, in the last 20 years or so, alternative dispute resolution (ADR) has become popular. Instead of going directly to court, ADR can include

mediation, arbitration, or both as an alternative. The difference between the two is important.

1. <u>MEDIATION</u> means that a third party listens to both sides and then helps the parties find a mutually acceptable solution. The mediator does not make any decisions. If the parties cannot agree on a solution, none is imposed.

2. <u>ARBITRATION</u>, by contrast, is sort of a mini-trial. Both sides present evidence and make arguments to an arbitrator, who then decides which party is in the right. A common criticism of arbitration is that there is often a "split-the-baby" decision in which both parties are unhappy.

Arbitration may be binding (it cannot be appealed to a court of law) or non-binding (it can be appealed). Whether it is binding or non-binding must be set out in the contract.

3. <u>LITIGATION</u> should always be a last resort. If the parties choose to go to court to resolve a problem, it is almost certain that both parties will spend a tremendous amount time and money to have a court decision. Sometimes this is the best or only way to resolve a matter. <u>All parties would be best served by hiring lawyers to represent them in the event of litigation.</u>

ATTORNEY'S FEES

Let's say you opt for litigation to resolve a dispute and you win. Is the other party obligated to reimburse you for the money you spent for your legal fees? It depends. Reimbursement is available only if there is a statute giving you that right, or a specific clause in the contract.

Each state has statutes, state laws, that allow for the recovery of legal expenses in certain specific disputes. Generally, the reason for such a statute is that the legislature wishes to discourage particular behavior that is considered against the public interest. The ability for a prevailing party to receive their legal fees, in addition to any other recovery, is intended to act as a deterrent against that behavior.

In a contract, an attorney's fees provision will generally state either that each party is responsible for its own legal costs, or that the prevailing party may request reimbursement from the opposing party by application to the court.

Whether by statute or contract, the possibility of paying attorney fees may deter frivolous litigation. At the same time, the potential for recovering litigation fees and costs can make litigation more viable for a party who might not otherwise be able to afford litigation.

REALITY CHECK: If you have an attorney fees provision in your contract, please do not assume that a lawyer will be happy to take your case on a contingent fee basis—that is, wait for payment until the end of the lawsuit and take a percentage of the monetary award. Lawyers are generally unwilling to take cases on a contingent fee basis unless the question is not whether but how much the other party will pay.

Even if a lawyer is willing to take a case on a contingent fee, you will have to pay out-of-pocket costs like filing fees, deposition fees, travel expenses, and copying costs. These can be substantial, depending on the nature and duration of the case.

NOTICES

Any notification required by the contract will be delivered in the way specified in a Notices clause. Events requiring notice can include:

>> Notifying the other party of performance problems,
>> Necessary changes to any of the terms of the agreement,
>> Or even of the intent to terminate.

Notices will generally be required in writing and sent to the addresses each party provides within the contract, by whatever means—U.S. mail (certified or not), email, or fax—the parties agree upon.

ASSIGNABILITY

Assignability refers to the ability of either party to assign the obligations of the contract to another party. In art-related contracts, it is rare that the artist will have any flexibility in this regard since the artist's work was likely chosen for its unique qualities and, therefore, could not adequately be performed by someone else.

However, the ownership of galleries and companies may change, as may administrations governing public art projects. Thus, the non-artist party to the contract may need to have a little more flexibility to

pass the contract along to the subsequent owner or administration. This may actually be a good thing for the artist since it means that, rather than terminating the contract, it can be completed and the artist fully compensated. Further, any ongoing obligations after completion, such as maintenance, will be honored.

On the other hand, the artist may want the option to terminate the contract rather than agree to assignment if the new party creates substantially different working conditions.

NON-WAIVER

If one party breaches the agreement, and the other party does nothing, contracts generally provide that the party who does nothing has not waived its future ability to enforce the terms of the agreement.

Lorenzo Medici signs a written agreement including a non-waiver clause with Michelangelo. The agreement is to commission Michelangelo to paint Lorenzo's dining room ceiling. Though no Sistine Chapel, Lorenzo's dining room is rather large and the project will likely take several months. Lorenzo promises to pay Michelangelo on the first of every month until the commission is completed.

The first month, Lorenzo pays on time.

The second month, Lorenzo pays 15 days late but Michelangelo, happy for the work, says nothing.

The third month, Lorenzo pays 10 days late. If Michelangelo wants to make an issue of the late payment, that is allowed because his acceptance of payment 15 days late the prior month does not constitute a waiver of the payment terms. Lorenzo is still required to adhere to the terms of the agreement.

Hopefully, with Lorenzo's talent for diplomacy, a reasonable solution will be reached before anyone resorts to legal action.

SIGNATURES

The last item on a contract is the signatures. Some-
times, it is necessary to notarize them; however, most
contracts only require a signature of an authorized
person, along with their title, if applicable, and a date.
The most important consideration to make is that the
person signing is, in fact, authorized to enter into the
contract. Just as it is important to pay attention to the
parties at the beginning of the contract, being aware
of the capacity of the person signing the contract is an
effective way to avoid claims down the road that the
contract was not validly entered into.

A final clause in the contract may be included that
allows signatures to be affixed in counterparts. This
means that there can be more than one original signa-
ture page, which together will constitute a completely
executed agreement. Faxed, emailed, scanned, or
other electronic transmission of signatures may also be
allowed. Either of these options provides a little more
flexibility and speed in executing a contract. The parties
do not need to be in the same place to sign or wait
for overnight mailing (and pay for it) to complete the
contract. Ultimately, however, it still makes sense for
someone to keep copies of original signatures—even
if they are spread over two or more copies of the
signature page.

EXHIBITS AND SCHEDULES

Often, a contract will also include exhibits or schedules attached after the signature page. These pages will describe details of the contract that might change during the course of performing the contract. Using exhibits or schedules is an effective way to efficiently create and change specific lists, parameters, or schedules for performance without altering the basic terms of the contract.

KEY POINTS

Of course, we've saved the best for last.

» Read carefully.

» Read carefully.

» Read carefully.

» Maybe consider getting a lawyer involved.

It's all here!

Chapter 8

READY TO GO

FOR ME, MAKING LISTS is a very good way to clarify
and establish goals. This is true whether I am
planning a trip to the market or establishing a
business strategy (I won't tell you which list is longer
or more interesting). Based on my general success with
list-making, I often recommend that others give it a
try too. When you do, you should certainly make a list
based on your specific needs and circumstances. But in
case you can use a little help getting started, following
are several items for you to think about when it comes
to managing your legal and contractual needs:

☐ BUILD A TEAM.
 Gather your own team of experts and advisors. Don't
 rely on others to do this for you. Interview and personal-
 ly retain each member of your support team.

☐ MAKE FRIENDS WITH A LAWYER.
 Establish a rapport with a lawyer, even if you don't need
 one yet.

☐ KEEP EDUCATING YOURSELF.
 Understanding contracts is, for better or worse, just the
 beginning. You must ultimately understand the business
 of art. Educate yourself about how galleries work, how
 art fairs and festivals are run, what museum curators
 look for in adding to museum collections, how work is
 valued for insurance purposes, how work is valued for
 sales and re-sales.

☐ DECIDE WHAT YOU WANT.
 Decide how you want your career to fit into the art
 world, and be purposeful in your efforts. You may
 decide you simply want to create work in the peace of
 your studio and don't care if you ever make a sale. That

is perfectly legitimate and can lead to a very satisfying artistic career. However, unless you are independently wealthy, you will have to support yourself in another way. If you decide to pursue a paying career as an artist, you will have to create a business plan for yourself and pursue business goals along with the artistic.

☐ BE PERSISTENT BUT FLEXIBLE.

☐ BE FLEXIBLE BUT PERSISTENT.

☐ THINK AHEAD.
You never know who will be in a position to buy, promote, or champion your work in the future. Anyone who shows interest along the way should be treated with respect and appreciation so that you not only develop your collector, patron, and support base, but also develop a network that can become part of your team of experts and resources.

☐ KEEP NOTES.
Taking notes during conversations and, better yet, following up conversations with a written note, is the best way to memorialize understandings. Before, during, and even after negotiating and finalizing a contract, notes of meetings and conversations are the best way for you to stay organized and on track. Relying on your memory for details of a conversation is a recipe for creating frustration and inaccuracies. Take notes, and file them in a project folder—you'll be surprised how often you refer back to them during the course of a project.

☐ SAVE YOUR PENNIES.
While more of a financial strategy (that I am fairly certain any financial advisor would agree with), saving as

much money as you can when you are earning it will give
you a better chance of weathering times when sales are
slow and projects few and far between. A "chicken today,
feathers tomorrow" attitude may work well for a while, but
it really is not a wise long-term strategy. Having a few
dollars set aside also gives you the ability to bring in those
experts when you need them. Ironically, knowing that
you have options and can afford to hire someone to help
you exercise them can provide you with that extra bit of
confidence needed for you to handle matters on your own.

☐ PACE YOURSELF.
All too often, early success means early burnout and dis-
appointment. Don't be lulled into a false sense of security
and infallibility if you are one of the lucky artists to enjoy
commercial and critical success.

☐ STAY CONNECTED.
Keep talking. While the notion of networking may be
as unpleasant as reading contracts, figure out a comfort-
able way for you to maintain connections. Build your
contacts. These are the people you can look to for moral
support, but they may also be a valuable resource for
recommendations for galleries, fabricators, and other
professionals that make your life easier and your projects
smooth. Who knows? Maybe they'll even recommend a
good lawyer.

Some of these items you may wish to incorporate as is; oth-
ers, you can tweak to fit your personal situation. In making
the list, you are on the way to creating your own business
plan, which will evolve as your career evolves. The list will
give you a good base from which to work and a place to
which you will return. Checking and revising your goals
will keep you moving forward in the right direction. Over

time, you will see that you are learning and adjusting your business tactics based on acquired experience and knowledge.

Expanding your abilities to include business acumen need not compromise your creativity, vision, or passion. By educating yourself about contracts, you not only protect yourself, you also raise the bar for all art-related business transactions. If artists approach contracts seriously and knowledgeably, every purchaser, seller, or commissioner of art will be forced to offer more respect and better terms for all artists and creative endeavors.

Appendix

SAMPLE
FORMS &
CONTRACTS

DISCLAIMER (YEP, THIS IS A BIG LEGAL DISCLAIMER, SO PLEASE READ IT CAREFULLY!)

The Sample Forms and Contracts provided on this lovely blue paper are included in this book for the purpose of giving you an idea of what actual agreements might look like and what language they might include.

Nothing in this Sample Forms & Contracts section should be considered in any way, shape, or form LEGAL ADVICE.

These Samples contain SAMPLE language (not to be considered suggested language) and, therefore, may not be appropriate for your situation. This SAMPLE language should not be used as is without consideration and/or modification based on your specific situation.

Depending on your particular situation, and the state or federal laws that apply, you may need more, less, or just different information in your particular agreement. Please use this as a way to guide your conversations and negotiations.

Before drafting or signing any agreement, you are strongly urged to find legal representation to ensure that your specific interests are represented and protected.

Another good source for sample language and more specialized forms is the Americans for the Arts Public Art Network resource page found at:
www.artsusa.org/networks/public_art_network/resources_tools.asp

I. CONTRACT CHECKLIST

› INTRODUCTION

☐ 1. DATE OF THE AGREEMENT

☐ 2. PARTIES TO THE AGREEMENT

☐ 3. "WHEREAS" CLAUSES
Setting out purpose and desires of the parties to the Agreement.

› BASICS

☐ 4. NATURE OF CONTRACT
a. Consignment
b. Commission
c. Employment/Independent Contractor

☐ 5. SCOPE OF THE CONTRACT
a. General description of work to be performed
i. Services
ii. Deliverables
b. Details of services or referral to attached Schedule A with details

☐ 6. TERM AND TERMINATION
a. With or without cause
b. Death or Incapacity

› BODY OF AGREEMENT

☐ 7. <u>PERFORMANCE SCHEDULE</u>
 a. Time is of the essence
 b. Extension of time

☐ 8. <u>PAYMENT</u>
 a. Salary, flat fee, based on performance benchmarks, or percentage of sales (if applicable)
 b. Automatic or invoiced. If invoiced, procedure for invoicing
 c. Costs: reimbursable or not
 d. Additional compensation in the event the Agreement is changed resulting in increased costs and/or scope of work
 e. Late payment procedures
 f. Royalties or additional compensation, including payment procedures for licensing or other types of sales
 g. Accounting rights and statements of inventory if applicable

☐ 9. <u>PROMISES, REPRESENTATIONS, AND WARRANTIES OF EACH PARTY</u>
 a. Representation regarding nature of each Party (i.e., corporation, individual, partnership)
 b. Representation that there are no other agreements or circum-stances that will cause a conflict or other difficulty in carrying out the terms of the Agreement
 c. Artist's warranty of originality for work created
 d. Representation and warranty by Client as to status of Site, provided materials, and/or any other prerequisites for carrying out the terms of the Agreement
 e. Representations and warranties as to the ownership of other intellectual property integrated into the project
 f. Representations and warranties as to the quality of deliverables

☐ 10. PROPERTY
 a. Ownership of IP and Physical Property
 b. Registration of copyright or other intellectual property protections
 c. Transfer of Title

☐ 11. PROCEDURE
 a. Change and Approval Process. This section should also include mechanism for revisions to deliverables if not approved.
 b. Indemnification
 c. Risk of Loss and Insurance matters need only be addressed in the event of the commission of the Artwork and/or its fabrication and/or installation. Client may wish to see some proof of insurance from the Artist, but since Artists cannot obtain insurance for design work, the parties may wish to discuss liability issues from the standpoint of strategies designed to limit exposure. Clients may wish to enlist the services of licensed professionals (like architects or engineers) to assure that the design process is sound. Artists may wish to establish that they are not responsible for liabilities resulting from the design and only responsible for completing the design deliverables as specified in the agreement.

› BOILERPLATE LANGUAGE

☐ 12. FORCE MAJEURE

☐ 13. NON-ASSIGNABILITY
 This generally applies to the Artist due to the unique nature of the Artist's services. The Client, however, may need to have the freedom of assigning the contract so that future owners may benefit from the art being designed.

☐ 14. SEVERABILITY

☐ 15. <u>GOVERNING LAW AND VENUE</u>

☐ 16. <u>NOTICES</u>

☐ 17. <u>DISPUTE RESOLUTION</u>
 a. Good Faith attempt to resolve
 b. Mediation
 c. Arbitration (binding or non-binding)
 d. Litigation

☐ 18. <u>ATTORNEY FEES AND COSTS</u>

☐ 19. <u>INTEGRATION</u>
 Establishes that the agreement consists only of what is in the agreement—no oral agreements or prior discussions apply.

☐ 20. <u>NONWAIVER</u>

☐ 21. <u>EXECUTION BY COUNTERPART AND FACSIMILE</u>
 This is so everyone does not have to be in the same place at the same time to get the document signed.

☐ 22. <u>SIGNATURE BLOCK</u>
 This may just require a signature and date but on occasion may also require notary sign and stamp. If you need a notary, check with your bank, post office, or, of course, your lawyer.

2. ANNOTATED CONSIGNMENT & REPRESENTATION AGREEMENT

A Consignment Agreement should be used whenever an artist is entrusting work to another party for the purpose of selling the work. The most obvious situation is when an artist is represented by a gallery. Beyond the basics of establishing that the artist retains ownership of the artwork until any sale is completed, this agreement should also lay out obligations and expectations for both the artist and the gallery.

> This Consignment & Representation Agreement ("Agreement") is made this _____ (Date) between: _____ ("Gallery") and _____ ("Artist")
> The parties, for good and valuable consideration and the promises contained herein, agree as follows:
>
> 1. SCOPE OF AGENCY Artist agrees that Gallery shall be Artist's exclusive/non-exclusive (circle one) agent for the sale and exhibition of Artist's artwork in _____ ("Geographic Area").

Generally, it's best to make sure that the Geographic Area is one in which the gallery is actually able to operate. Be suspicious of worldwide representation agreements if the gallery is really a local business with little or no international connections. On the other hand, a gallery that travels around the world to all the art fairs might have a legitimate claim to a worldwide territory—just make sure they are still helping to establish relationships with other galleries around the globe as needed to establish your international presence.

> 2. TERM OF CONTRACT AND TERMINATION The term of this Agreement shall be for one year commencing on the date of this Agreement. Either party can terminate this agreement at any time by giving the other sixty (60) days prior written notice. This Agreement shall automatically terminate without notice upon the death, disability, incapacity, dissolution, or bankruptcy of either party. Upon termination, Artist's work shall be removed from Gallery at the expense of the terminating party within thirty (30) days of the date of termination.

Some would object to such a flexible termination policy. In my experience, it is always preferable in creative endeavors, especially relationships as complex as artist-gallery, to make termination as fair as possible. Take into account the investment of each party as well as the importance of being emotionally engaged in the relationship. Further, I find that no one reacts well to feeling trapped, and if termination is too difficult, it tends to sour the relationship rather than strengthen it.

3. CONSIGNMENT Subject to the terms of this Agreement, Artist hereby consigns to Gallery the works listed in the attached Inventory List marked as Exhibit A ("Inventory List"). Any subsequent works delivered by Artist and accepted by Gallery shall be listed in a separate inventory list ("Subsequent Inventory List") that shall be signed by both parties. All Subsequent Inventory Lists shall be subject to this Agreement and are incorporated herein by reference.

It is really an important part of running a business to keep careful track of what work has been sent out and to whom. The gallery should always notify the artist of any sales so that all parties' records can be updated accordingly. Artists should plan to regularly take inventory of what has been sold and what remains in the gallery. If pieces are unaccounted for, someone will need to begin an investigation to figure out where that work is. It has certainly been known to happen that a sale has gone unreported—inadvertently or not—and it is important to reconcile records on a regular basis.

4. DUTIES AND WARRANTIES OF GALLERY

4.1 REASONABLE EFFORTS For the term of this Agreement, Gallery shall use reasonable efforts to promote, advertise, sell, and exhibit Artist's works. Additionally, Gallery shall use reasonable efforts to promote Artist and further Artist's career. To this end, Gallery shall inform Artist of juried exhibitions, museum exhibitions, other opportunities for gallery showings and exhibitions, and other shows or competitions as they become known to the Gallery.

This description may vary from gallery to gallery given that galleries differ in their strengths, abilities, and willingness to assist in various career opportunities. This is a very good area for discussion prior to entering into an agreement so that both parties are on the same page with regard to what the gallery will do.

4.2 ACCEPTANCE OF ARTWORK Gallery reserves the right to refuse to accept artwork for consignment if Gallery determines that artwork is too fragile, poorly crafted, expensive, or difficult to exhibit and store.

ANNOTATED CONSIGNMENT & REPRESENTATION

4.3 <u>EXHIBITIONS</u> Gallery shall arrange for the exhibition of Artist's works in the Geographic Area set forth in Section 1 and such other places as the parties shall jointly determine. Gallery shall arrange for solo exhibits of Artist's works at least once every _____ months. [Gallery shall arrange for solo exhibits of Artist's work when, in Gallery's sole discretion, Artist has enough work appropriate for a solo exhibit.] Gallery shall be responsible for the cost for designing, printing, and mailing advertisements that, in the Gallery's sole discretion, are most appropriate for the exhibition. The cost for any additional advertising materials for such exhibitions, including, but not limited to, catalogues and other promotional materials in connection with such exhibitions, shall be shared equally by Artist and Gallery.

The responsibility for promotional campaigns and who bears the cost can vary quite a lot from place to place. Again, this is something to discuss so that all parties understand what is expected. That being said, galleries should definitely be offering artists something more than blank walls on which to hang their work, but on the flip side, should not be expected to bear unreasonable costs for expensive promotion that may not be appropriate or effective for every artist.

4.4 <u>DUTY OF CARE REGARDING ARTIST'S WORK</u> Gallery shall assume full responsibility for artwork in its possession and control and shall use the highest standard of care when transporting, displaying, storing, or otherwise handling Artist's work.

4.5 <u>INSURANCE</u> Gallery shall maintain insurance on all works listed in the Inventory List and Subsequent Inventory Lists against damage by fire, any damage sustained during Gallery's transportation of work, damage incurred at any location outside of the Gallery where work is being shown, and other dangers set forth in most current standard extended coverage endorsement in an amount equal to at least fifty percent (50%) of the artwork's retail price, with a _____ dollar ($ _____) deductible. In the event of an insurable loss, Artist shall be entitled to a percentage of the total recovered amount less the deductible, as determined by Section 7 of this Agreement.

Many galleries are reluctant to carry full coverage as it can be very expensive. This is not ideal, but we must be realistic. Artists should check with their insurance company to see if there is any way to extend coverage to work outside of the studio when it is consigned. Because consignment means that the work still belongs to the artist despite the fact that it is in someone else's possession, some companies may offer some protection.

4.6 REPAIRING DAMAGED WORK In the event that Artist's work is damaged or broken, the Gallery and the Artist shall determine whether the work can be repaired. Artist shall be paid for repair time as agreed upon before repair is attempted. If Artist's work is unable to be repaired, Artist shall receive fifty percent (50%) of original retail price.

5. DUTIES AND WARRANTIES OF ARTIST

5.1 DELIVERY OF ARTWORK Artist shall be responsible for the delivery of all artwork to Gallery. Upon delivery, art shall be in condition to be exhibited immediately. Work shall be matted, framed, wired for hanging, or otherwise properly prepared for exhibition. Sculpture shall be accompanied by bases when necessary unless otherwise agreed by Gallery and Artist. Artist may arrange in advance for Gallery to prepare Artist's work for exhibition. Arrangements must be made at least thirty (30) days in advance. If appropriate arrangements are not made and/or artwork is not delivered in proper exhibition condition, Gallery shall be entitled to deduct from payment due Artist under Section 6, any expenses incurred. Artist must sign and date each artwork before delivering the work to Gallery.

5.2 INVENTORY Artist agrees to provide Gallery with new inventory at least every _____ months or as otherwise arranged. Gallery reserves the right to return, at Gallery's expense, any works which do not sell within a reasonable time to be determined by the Gallery. Any returned inventory may not be consigned to any other location within the scope of this Agreement as set forth in Section 1.

Depending on how prolific an artist is, expectations for new work will change accordingly. Artists should always be realistic in what is promised up front. Galleries tend to be

ANNOTATED CONSIGNMENT & REPRESENTATION

very understanding as long as their expectations are set from the beginning. In either case, clear communications and periodic studio visits can be very helpful.

5.3 <u>INVENTORY LISTS</u> Artist shall provide Gallery with complete Inventory Lists, in accordance with Section 3 of this Agreement, upon the delivery of any new work to Gallery. Inventory lists are important so that you can account for what has or has not been sold. See the sample Inventory List following this sample contract.

5.4 <u>PHOTOGRAPHS</u> At least ninety (90) days before any upcoming exhibition, Artist shall either provide, or pay the cost of time and services for Gallery to obtain, digital photographs for at least two (2) pieces of artwork. Artist shall indicate: Artist's name; title, size, and medium of piece; direction in which piece is to be displayed; and date for each image. These images shall, unless otherwise agreed, be used for the sole purpose of promoting exhibition of Artist's artworks at Gallery.

Or the gallery may take on this expense as part of what is provided to the artist under the terms of the agreement. In either case, make sure that the photographer grants the rights you need to use the photos without having to go back for permission each time.

5.5 <u>SLIDES [OR CD OR OTHER ELECTRONIC MEDIUM]</u> For all works consigned to Gallery, Artist shall either provide, or pay the cost of time and services for Gallery to obtain, one (1) master set of professional quality, annotated, color slides and one (1) annotated, color duplicate [or add equivalent description for electronic media of choice]. Gallery shall be responsible for the cost of any additional duplicates. Slide [or other media] annotations shall include: Artist's name; title, size, and medium of piece; direction in which piece is to be displayed; and date.

Obviously, slides may be a little out of date these days, but it is important to include a complete description of the manner in which the gallery wants information about the artwork transmitted. This information is used to put together all sorts of promotional material and website presence. If the artist has any misgivings about the way in which images and/or other information about the artist and the artist's work are displayed, that should be clearly communicated to the gallery prior to handing over such media.

5.6 <u>RESUME MATERIALS</u> Artist shall ensure that Gallery has Artist's current resume on file at all times. In addition to a current resume, Artist shall provide Gallery with copies of newspaper, magazine, or journal articles written by or about Artist. All copies shall include name, date of publication, author, and location of article by page number.

This is important material not only so that the gallery remains up to date in the artist's endeavors but also for artist to maintain as a basic element of running a business.

5.7 <u>WARRANTIES OF ARTIST</u> Artist represents and warrants that she is the creator of all artwork described in the Inventory List and all Subsequent Inventory Lists. Artist represents and warrants that she possesses unencumbered title to the artwork and that she has full authority to enter into this agreement. Artist shall not make any other agreements to encumber, sell, transfer, or subject the artwork to any lien, charge, or restriction during the term of this Agreement without the prior written consent of Gallery. Works intended for exhibition shall not be pre-sold by Artist.

If you do happen to pre-sell any work, make sure you confer with the gallery first and negotiate the commission split.

6. <u>PRICING AND SALES OF ARTIST'S ARTWORK</u>

6.1 <u>PRICING OF ARTIST'S ARTWORK</u> All retail prices shall be discussed and decided by mutual agreement of the parties. Upon agreement, such retail prices shall be noted on the Inventory List or appropriate Subsequent Inventory List. Discounts of up to _____ percent (_____%) shall be shared by the parties. The Gallery shall absorb the cost of any further discount. Any possible sales commissions which will become payable upon sale of artwork shall be taken into account in determining a fair retail price.

This is a place where the gallery must be clear in what it thinks an artist's work is worth. This may be difficult for the artist to hear, but it's even worse if the gallery is vague so as to avoid confrontation with the artist and then the artist finds out the lower-than-expected price later. It is also imperative that the gallery notify the artist if the gallery has decided that it makes sense to raise or lower prices from the level originally agreed upon. Once again, communication is the key!

6.2 <u>SALES ON APPROVAL</u> Artist's artwork may, upon payment of a deposit in the amount of the artwork's retail price, be removed from Gallery's premises for purposes of sales on approval. Artwork shall not be left longer than two (2) weeks with a potential purchaser without Artist's consent. Artist shall not unreasonably withhold consent so long as Gallery has obtained a deposit in the amount of the artwork's retail price.

This is another area that is certainly up for discussion. The main point is that no one wants the artist's work out in someone's home or business for very long before getting paid—or having the work returned. The best policy is to get a deposit from the collector at the time that the work goes out. This does not always happen. In any event, the gallery needs to take responsibility for these arrangements as the artist is not in a position to do so (nor in most cases would the gallery want the artist involved in this part of the selling process!).

6.3 <u>INSTALLMENT SALES</u> Artist's artwork may be sold by installment sale. The period for payment of installments shall not exceed twelve (12) months without the Artist's prior written consent. Should Gallery violate this paragraph, such sale shall be treated as a sale as described in Section 7.2.1, making fifty percent (50%) of the total sale price due to the Artist upon the time of such sale, regardless of when the total price is paid to the Gallery. If the sale of the Artist's work is on installment, Gallery shall pay the Artist that percentage due Artist, pursuant to Section 7, from each payment within thirty (30) days of receipt.

Because the work is consigned, the artist could legitimately argue that all of the payments should go to the artist until the entitled percentage is paid, leaving the gallery responsible for collecting its 50% at the end. However, in the spirit of cooperation, it is a reasonable compromise to split each payment as it comes in so both parties share the risk.

7. <u>COMMISSIONS AND STATEMENTS OF INVENTORY</u>

7.1 <u>GALLERY COMMISSION</u>

7.1.1 <u>WITHIN GEOGRAPHIC AREA</u> For each piece of Artist's artwork sold by Gallery or agents of Gallery, within the Geographical Area, Gallery shall receive a commission of _____% (_____ percent) of the retail price. [50% is fairly standard but can vary depending on the parties.] For each piece of Artist's artwork sold through another Gallery within the Geographic

Area, Gallery shall be entitled to receive at least _____
percent (____%) of the retail price.

Here, 15%–20% is the general ballpark but can vary dramatically depending on
the situation.

7.1.2 OUTSIDE GEOGRAPHIC AREA Unless a sale is initiated by or
through Gallery or agents of Gallery, Gallery shall not receive
any commission for any work sold outside the Geographical
Area. If a sale outside the Geographic Area is initiated by
or through Gallery or agents of Gallery, Gallery shall receive
_____ percent (____%) of retail price less deductions for sales
or other taxes.

This percentage is generally the same as a sale made within the geographic area
since the gallery has done the work to make it happen. Where another party has been
involved with the sale, it may be appropriate to reduce compensation accordingly.

7.1.3 COMMISSIONED ARTWORK
7.1.3.1 ARRANGED BY GALLERY For any private or public commissions
arranged through Gallery or agents of Gallery, Gallery shall
receive _____ percent (_____%) of the sale price.

This amount can range but is generally in the 30-50% range.

7.1.3.2 ARRANGED BY ARTIST For private or public commissions
arranged by Artist, Gallery shall be entitled to _____ per-
cent (___%) of the sale price of those artworks that are to
be installed within the Geographic Area. For public or private
commissions arranged by Artist where work is to be installed
outside of the Geographic Area, Gallery shall receive no
percentage of the sale price.

This is generally a much smaller amount in the 10%–20% range. The reason for any
commission at all is that at a certain point it becomes impossible to really tell why a sale
happens and how much of it is due to the work of the gallery in promoting the artist.
Depending on the circumstances, a gallery may not require a percentage be paid, but it
is not unreasonable for them to do so.

ANNOTATED CONSIGNMENT & REPRESENTATION

7.1.4 <u>STUDIO SALES</u> For any sales made by the Artist out of Artist's studio, located within the Geographical Area as set forth in Section 1, in which Gallery is not involved either in directing purchaser to artist or directing artist to purchaser, Gallery is entitled to _____ percent (___ %) of the sale price. For any sales made by the Artist out of Artist's studio, in any geographical area, in which Gallery is involved either in directing purchaser to artist or directing Artist to purchaser, Gallery is entitled to _____ percent (_____ %) of the sale price.

The first amount should also be in the 10%–20% range as an artist should be entitled to some benefit for selling out of the artist's studio. However, if the artist feels that it is appropriate to sell out of the studio at a discounted price in order to avoid the gallery commission, the artist is really damaging his or her reputation and the value of the artwork. Why would collectors go to the gallery and pay higher prices if it's known that the artist sells at a discount out of the studio? The second amount is generally the same percentage as a regular gallery sale—so probably in the 50% range. This makes sense because the gallery has made the sale and done its job even if the artwork is not actually located in the gallery at the time of the sale.

7.2 <u>ARTIST COMMISSION AND STATEMENTS OF INVENTORY</u>

7.2.1 <u>ARTIST COMMISSION</u> Proceeds from the sale of Artist's work shall be paid to Artist in full within _____ (_____) days from Gallery's receipt of payment, unless artwork is sold by installment sale in which case payment shall be made in accordance with Section 6.3.

This should really be 30 to 60 days. As soon as gallery receives money, it is technically the property of the artist. Unfortunately, too many galleries have to rob Peter to pay Paul so that can slow down the payment process. As with any good business, if there is an issue with remitting payment to an artist on time, the gallery should notify the artist and make sure they can mutually agree on an acceptable way to handle the situation.

7.2.2 <u>STATEMENT OF INVENTORY</u> Along with payment of proceeds to Artist, or upon written demand from Artist, Gallery shall furnish Artist with [a list of works sold and the names of the purchasers, the dates of purchase, and the price paid for any sale totaling one hundred dollars ($100) or more.]

Many galleries are reluctant to provide this sort of information to artists. Galleries don't want to build up a collector base for the artist only to have the artist run off to another gallery. However, you should check your state's laws because some states require

information to be provided. In any event, it is important for artists to be able to maintain information regarding where their work is so that it can be borrowed in the event of a museum show or retrospective.

8. COPYRIGHT All copyright and further reproduction rights to Artist's consigned artwork shall remain with Artist. Artist shall sign and date each piece before delivery to Gallery. Any rights transferred with respect to this Section 8 shall be in writing.

It is nice if galleries can put this information on sales invoices so that collectors know this as well.

8.1 PROTECTION OF COPYRIGHT Gallery shall take all steps necessary to ensure that Artist's copyright is protected. Gallery shall inform any and all purchasers of Artist's artwork that the copyright to such work remains with Artist and that the copyright is not transferred to the purchaser unless otherwise stated in writing by Artist.

8.2 GALLERY'S USE OF IMAGES Artist agrees to allow Gallery to reproduce images of Artist's artwork in catalogues, articles, and other promotional materials, and otherwise use images of Artist's artwork for purposes of advertising, promoting, and selling Artist's artwork, and to otherwise further the career of Artist.

Again, good to be aware of where images will be. If images are posted online, the artist may want to be sure that they are not copyable or downloadable and/or digitally watermarked to provide some means for protection. On the other hand, so much business is done online these days that too much restriction may be an unnecessary hindrance to the gallery.

9. SEVERABILITY If any term of this Agreement is held to be illegal, void, or unenforceable for any reason, such holding shall not affect the validity and enforceability of any other term of this Agreement.

10. GOVERNING LAW AND VENUE This agreement shall be governed by and construed in accordance with the laws of the State of _____ . Any disputes that arise shall be resolved in the courts in the State of _____ .

ANNOTATED CONSIGNMENT & REPRESENTATION

Pay attention to which state applies here so you know what law applies and where you will have to go if you have a dispute. While unusual, it is possible that the governing law will be a different state than the venue. Just pay attention!

11. ENTIRE AGREEMENT This Agreement supersedes and replaces all prior written and oral agreements and constitutes the entire and complete agreement by and between Artist and Gallery.
This Agreement may be changed only by an agreement in writing, signed by the party against whom enforcement of any modification, extension, or discharge is sought.

This means that oral agreements outside of what's written in the Agreement need not be honored. Be careful that all that you were promised is in the actual, written Agreement.

12. MEDIATION Any dispute arising out of this Agreement shall first be subject to mediation upon _____ (_____) days notice. If the parties are unable to agree on a mutually acceptable mediator, or if mediation is not completed within _____ (_____) days from the date of notice, or if the mediation is not successful in resolving the entire dispute, either party may seek legal resolution in accordance with the laws of the State of _____ .

The time frame for mediation should be short. A normal period for notification would be in the two-to-three-week range. Time for completion must take into account everyone's schedules, including the mediator. So, a 60 to 120-day period for completing the mediation is a reasonable range. Even if an Agreement doesn't contain a mediation clause, mediation is an option open to the parties upon mutual agreement. Mediation is often a less expensive and more expeditious way of resolving a dispute short of going to court.

13. ATTORNEY'S FEES The costs of mediation and/or arbitration shall be borne equally by the parties. In the event of litigation arising out of, or in any way related to, any term set forth in this Agreement, the prevailing party, in addition to any other relief awarded, shall be entitled to recover its reasonable attorney's fees and court costs at trial and on appeal.

Attorney fees to the prevailing party is a way to discourage frivolous suits and also provide a party with fewer resources to still be able to feasibly take a matter to court if necessary. Attorneys look for this clause right away when evaluating whether to take a case on. However, the client is still responsible for fees and costs and this language allows for potential reimbursement in the event of a victory.

14. <u>NOTICES</u> All notices required by this contract shall be in writing and mailed to the parties at the addresses set forth above or at such other address that a party shall specify in a notice given in accordance with this Section 14.

There can be additional language here too setting out the way in which notice is effective and can allow notice via email. The problem with email, of course, is that it is not as reliable, and with a paper notice, you can track the notice and require a signature to verify receipt.

15. <u>NON-ASSIGNABILITY</u> The rights and obligations contained in this Agreement are not assignable by either party without the express written consent of the other party. Gallery shall immediately notify Artist of any ownership or relevant personnel changes.

16. <u>NONWAIVER</u> The waiver by any party of a breach or violation of any term of this Agreement by the other party shall not operate or be construed as a waiver of any subsequent breach.

17. <u>EXECUTION OF AGREEMENT</u> This Agreement may be executed in counterparts and by facsimile.

Here, too, additional language can allow for various methods of execution. In addition to facsimile, many agreements now are executed in counterpart via scanned email documents. As long as everyone is fine with this, it's not a bad way to go!

GALLERY

By: _____

ARTIST

By: _____

ANNOTATED CONSIGNMENT & REPRESENTATION

3. SAMPLE INVENTORY LIST

Gallery confirms receipt of Artist's consigned works, in perfect condition unless otherwise noted, as follows:

#	TITLE:	
Medium:		
Size:		Retail value:
Notes:		
#	TITLE:	
Medium:		
Size:		Retail value:
Notes:		
#	TITLE:	
Medium:		
Size:		Retail value:
Notes:		

GALLERY
Name: _____
Date: _____
Address: _____
Signature: _____

ARTIST
Name: _____
Date: _____
Address: _____
Signature: _____

4. WORK MADE FOR HIRE AGREEMENT

A Work Made For Hire Agreement should be used anytime you want to have complete ownership or control of the work product generated by the project. This may be crucial when working with fabricators on a project you have conceived or in establishing an identity through developing a logo or website.

This Agreement is between _____ (Company) and _____ ("Contractor") for _____ ("Artwork").

1. SCOPE The parties expressly agree that Contractor is providing the Artwork on a Work for Hire basis, as an independent contractor and not an employee. In no event will Company be responsible for any insurance, benefits, or taxes of any sort on behalf of Contractor.

2. PAYMENT Contractor shall be paid _____ (the "Fee"). This sum shall be paid _____ [insert payment schedule].

3. INTELLECTUAL PROPERTY In exchange for the Fee, all artistic, literary and other artwork of whatever kind or nature, created or furnished by Contractor, and all other results and proceeds of any of Contractor's services in connection with the Artwork were or shall be created by Contractor solely as a "work made for hire" specially ordered or commissioned by Company with Company being deemed the sole author of the Artwork and owner of all rights of every kind or nature and in any and all media, whether now known or hereafter devised (including, but not limited to, all copyrights) in and to the Artwork throughout the universe, with the right to make any and all uses of the Artwork throughout the universe and all changes in or to the Artwork as Company deems desirable.
 >> If Company shall be deemed not to be the author and owner of the Artwork, then Contractor irrevocably transfers and assigns to Company all right, title, and interest in and to the Artwork for no additional consideration.

INVENTORY LIST / WORK MADE FOR HIRE

>> Contractor waives all rights under 17 U.S.C. § 106A et seq., the Visual Artists' Rights Act, and any other droit morales or moral rights to which he may otherwise be entitled.

4. CONTRACTOR'S WARRANTIES AND REPRESENTATIONS Contractor warrants and represents that: (1) Contractor has the right, authority, and power to execute this certificate; and (2) Except to the extent based on artwork provided by Company to be used as the basis for developing the Artwork, the Artwork (a) is or shall be original to Contractor, (b) does not and shall not infringe or violate copyright, trademark, the rights of privacy or publicity, or any other rights of any person or entity, and (c) is not and shall not be the subject of any litigation or other proceeding or claim that might give rise to litigation or any other proceeding.

5. INDEMNIFICATION Contractor shall indemnify and hold harmless Company and its successors, assigns, representatives, employees, officers, and directors for expenses (including without limitation, attorneys fees and court costs, whether or not in connection with litigation) that is inconsistent with any of the covenant, representations, and/or warranties Contractor makes herein.

5. TERMINATION Company shall have the right to terminate this agreement upon written notice in the event that (i) Contractor fails to complete and deliver the work on the agreed deadline or (ii) the work is not satisfactory to Company. In the event of termination, Contractor shall be entitled to retain payments up to the time of termination and all Artwork in whatever stage of completion shall become the property of Company pursuant to the terms of this Agreement.

6. ADDITIONAL DOCUMENTS Contractor agrees to execute any documents and do any other acts as may be required by Company or its assignees or licensees to further evidence and/or effectuate Company's rights as set forth in this Agreement. Should Contractor fail promptly to do so, Contractor appoints Company as his attorney-in-fact for such purposes (it being acknowledged that such appointment is irrevocable and coupled with as interest) with full power of substitution and delegation.

7. NAME AND LIKENESS Company, if it so desires, shall have the right to use Contractor's name and likeness with the Work, or any modification, translation, or derivative work thereof.

8. DISPUTES In the event there are any disputes, the parties agree to use best faith to resolve such disputes to mutual satisfaction through direct communication. If the parties are unable to resolve the problem or dispute within thirty (30) days, the matter will be submitted to mediation, or to such other form of dispute resolution to which the Parties may then agree. The mediation will be conducted by a neutral person acceptable to both parties. If mediation is not successful in resolving the entire dispute, any outstanding issues shall be submitted to binding arbitration by a professional arbitrator acceptable to the Parties. The arbitrator will be chosen from a panel of attorneys knowledgeable in the field of art and business law. The Arbitration shall be conducted in accordance with the rules of the American Arbitration Association.

9. GOVERNING LAW AND VENUE This Agreement shall be governed, construed, interpreted, enforced, and performed in accordance with the laws of the State of _____ and the United States of America. Any legal action or proceedings arising from this Agreement shall be filed and conducted within the State of _____ in the County of _____ . The prevailing party is entitled to recover reasonable costs and attorney fees.

10. ENTIRE AGREEMENT This Agreement sets out the parties' entire understanding. This Agreement supersedes all prior understandings, communications, and agreements. Any modification or amendment to this Agreement must be done in a written document signed by both parties.

FOR COMPANY

By: _____

Signature: _____

Print name: _____

CONTRACTOR

By: _____

Signature: _____

Print name: _____

SSN: _____

WORK MADE FOR HIRE

5. INTELLECTUAL PROPERTY / COPYRIGHT TRANSFER AGREEMENT

This Intellectual Property / Copyright Transfer Agreement ("Agreement")
is made effective _____ (Date), by and
between: _____ ("Author"),
and _____ ("Owner").

WHEREAS Owner engaged Author specifically to create _____
(the "Work"); and

WHEREAS Author created the Work; and

WHEREAS Owner wishes to acquire all right, title, and interest to the
Work; and

WHEREAS Author agrees to transfer all intellectual property rights in the
Work to Owner;

It is hereby agreed that:

The Work is a work made for hire, and all intellectual property rights,
including, but not limited to, copyright and trademark interests, in the
Work are hereby transferred to the Owner. Author retains no right, title,
and/or interest to the Work.

Dated this _____ day of _____ ,

AUTHOR
Signature: _____
Print Name: _____

OWNER
Signature: _____
Print Name: _____

6. MODEL RELEASE AGREEMENT

It is always best practice to get a Model Release anytime you are using another's image or likeness in a work. This document should be kept in your files forever in case any questions as to permission are raised.

I do hereby give _____ ("Artist"), his assigns, licensees, and legal representatives the irrevocable right to use my name (or any fictional name), picture, portrait, photograph, and/or performance(s), taken or recorded at any time or place, in all forms and media now known or hereinafter devised, in all manners, including composite or distorted representations, and for any other lawful purposes, including, but not limited to, any derivative works, throughout the world in perpetuity, and I waive any right to inspect or approve any finished product, including paintings and drawings, that may be created in connection therewith.

I affirm that all poses, positions, and situations enacted pursuant to this Release were entered into without force, coercion, or threat whatsoever, and were posed freely by me (and with my parent's consent, if applicable). I further agree to hold blameless and free of all accusation of such force or coercion Artist, his legal representatives, assigns, and those acting under his permission and on his authority.

I understand that there will be no monetary compensation now or ever in connection with the use of my name and image as allowed by this Release. I am of full age.* I have read this release and am fully familiar with its contents.

Signature: _____ Date: _____
Print Name: _____
Address: _____

*CONSENT (IF APPLICABLE)
I am the parent or guardian of the minor named above and have the legal authority to execute the above release. I approve the foregoing and waive any rights in the premises.
Signature: _____ Date: _____
Print Name: _____
Address: _____

7. ANNOTATED AGREEMENT FOR ARTWORK COMMISSION

Commission Agreements come in a variety of shapes and sizes. Often, if it is a municipal organization commissioning the work, there is little that the artist will be able to change in the language of the agreement beyond the scope and schedule. This is because municipal agreements are normally vetted by several people and approved by the city council or equivalent body. Nevertheless, this form should give you some idea of what *should* be included in the agreement, and a little bit of why.

This Agreement for is made and entered into this
_____ (Date), by and between _____
(Date), located at _____ ("Owner"),
and _____ , located at _____ ("Artist");

WHEREAS, in order to comply with [site policy or ordinance requir-ing public art here], Owner wishes to have Artist design, engineer, and construct a new work of art titled _____ (the "Artwork") to be located _____ ("Site");

This first section establishes who, what, where, and why (if there is an applicable ordinance or policy).

WHEREAS, Owner [and public art approval body] approved the Art Plan ("Design") for the Artwork;

Often the process of approving a public art project involves more than just the property owner. There may very well be local, county, or state guidelines impacting the project. Where the public art is being commissioned to satisfy an outside requirement, it is likely that failure to follow the governing body's guidelines or obtain proper approvals could result in the owner being unable to obtain a certificate of occupancy for the property.

WHEREAS, Artist is in the business of creating original works of art for site-specific installations;

This is an important point in that all artists are not competent in creating public artwork. This is not an insult to artists, simply a clarification that the process for creating studio art appropriate for a gallery show is very different from the process required to create public artwork appropriate for installation in a public setting. The differences involved in creating public art should become clear as you read through the text of this contract!

WHEREAS, the Parties understand and agree that time is of the essence.

Timing is often a crucial element to public art contracts. The artist and owner must spend some quality time discussing their respective schedules and performance constraints. This is always a fundamental aspect of making a public art project successful.

NOW, THEREFORE, for good and valuable consideration, the receipt and sufficiency of which are acknowledged, the parties agree as follows:

1. SCOPE OF ARTIST'S SERVICES Subject to the terms and conditions of this Agreement, and the performance and payment schedule set out in Exhibit A attached to this Agreement and incorporated by reference, Owner commissions Artist to design, fabricate, and construct or cause his agents to fabricate and construct, deliver, and install the Artwork for the Site.

 a. FABRICATION PLANS Using the already-approved conceptual design, attached to this Agreement as Exhibit B and thereby incorporated into this Agreement, Artist shall develop plans and engineering for the fabrication of the Design ("Fabrication Plans").

 b. FABRICATION Upon approval of the Fabrication Plans and receipt of payment pursuant to Exhibit A, the approved Fabrication Plans shall be added to and included in Exhibit B and thereby incorporated into this Agreement. Artist shall proceed with the construction of the Artwork pursuant to the Fabrication Plans ("Fabrication").

 c. DELIVERY Once Fabrication is complete, and Artist's receipt of payment pursuant to Exhibit A, Artist shall cause the Artwork to be delivered to the Site for installation.

 d. INSTALLATION As soon as reasonably possible, Artist or Artist's agents will install the Artwork in conformance with the installation and site specifications set forth in Exhibit C attached hereto and incorporated into this Agreement.

ANNOTATED ARTWORK COMMISSION

e. <u>TRANSFER</u> Upon the completion of Installation, and upon Artist's receipt of final payment, Artist shall transfer ownership to Owner.

Generally, by the time you get to a contract like this, there has already been an extensive proposal and review stage so that the artwork should be fairly well-determined. There may be details to be worked out and engineering to establish which could end up changing the artwork along the way. However, experienced public artists have a fairly good idea of what's going to be feasible from the beginning and may even have enough of a relationship with engineers and fabricators to run the project by them before getting to the contract phase.

2. <u>ARTIST'S COMPENSATION AND EXPENSES</u>

a. <u>COMPENSATION</u> Total compensation amount for the Project is $ _____ . The Artists has been paid a Conceptual Design fee of $ _____ to be subtracted from this amount. Therefore, Owner will pay Artist the remaining amount of _____ Dollars ($_____.00) (the "Contract Amount") pursuant to Exhibit A. This amount includes a contingency of _____ Dollars ($_____.00). Any portion of the contingency that remains unused at the end of the Project shall be paid to the Artist. However, if the contingency is exhausted prior to completion of this Agreement, any additional cost overruns are the sole responsibility of Artist.

Creating a realistic budget is not only a talent but a necessary component to succeeding in the world of public art. Without a budget, you will have no idea what your compensation should be and how it should be parsed out over the life of the project. Artists learn over time what is possible and where costs are likely to increase during the course of a project. If you are new at doing this, it would be very helpful to get some guidance from an artist who has a bit more experience.

b. <u>ARTIST'S ATTENDANCE AT MEETINGS</u> Artist shall meet and confer with Owner's representatives as needed to accomplish the Project.

c. <u>PAYMENT PROCEDURE</u> Payment as set forth under this Agreement will be made payable to "_____" and will be remitted by check to the address indicated in Paragraph 27, below. Artist agrees to stay current with his obligations to subcontractors and shall provide lien waivers or equivalent confirmations that subcontractors have been appropriately paid out of the funds paid

to Artist. [Invoices must be submitted according to the form as provided to Artist and attached hereto as Exhibit ___.] [There is no form invoice, but all invoices should be detailed enough that someone not familiar with this Agreement could reasonably determine the basis for the invoice charges.] All invoices received by the end of the month shall be paid no later than the _____ of the following month.

Lien waivers are documents showing that you paid your subcontractors. Owners are particularly sensitive to this because if the owner pays you money and you do not pay your subcontractors, it is possible that the subcontractors could come back to the owner for payment, essentially forcing the owner to pay for the work twice so as to avoid a lawsuit from the subcontractor for non-payment.

 d. INDEPENDENT CONTRACTOR Artist is furnishing his services as an independent contractor, and nothing in this Agreement creates any association, partnership, or joint venture between the Parties or any employer-employee relationship. Owner shall not withhold or pay with respect to any sums due under this Agreement any federal, state, or local income taxes (domestic or foreign), FICA, Medicare, unemployment insurance, workers compensation insurance, or other taxes or assessments against amounts otherwise payable with respect to statutory employees. Artist agrees to hold harmless, indemnify, and reimburse Owner for any taxes, premiums, assessments, and other liabilities (including penalties and interest) that Owner may be required to pay. Artist shall also assure that any subcontractors comply with the foregoing obligations. Artist shall be solely responsible and liable for all such obligations, and Artist agrees to hold harmless, indemnify, and reimburse Owner for any taxes, premiums, assessments, and other liabilities (including penalties and interest) that Owner may be required to pay. During the term of this Agreement, unless otherwise agreed to in writing, subcontractors shall at all times remain under Artist's sole control.

 e. SALES AND USE TAX This commission may be subject to state sales and/or use tax laws. [Owner shall be responsible for the filing

and payment of any taxes due on the Artwork.] [Artist shall be responsible for budgeting, filing, and paying taxes due on the Artwork.]

Sales and Use Tax is an area that has become increasingly problematic as states are short on funds. Whenever possible, it is wise to get a specific opinion from the taxing authority as to what the exposure on a particular project will be.

3. FABRICATION AND INSTALLATION PLANS

a. Fabrication and Installation Plans (the "Plans") shall include all details pertaining to the fabrication and execution of the Design for the Artwork as well as the necessary specifications for Installation at the Site ("Site Specifications"). Artist is responsible for obtaining appropriate design and/or engineering services from licensed professionals as necessary for proper Fabrication and Installation of the Artwork. The design and engineering work shall be performed by qualified architects, engineers, electricians, and/or other design professionals who are licensed in the State of _____, and in a manner consistent with applicable standards of professional skill, care, and diligence.

b. Artist is responsible for providing Owner with all necessary specifications for constructing and preparing all specialized aspects [for example: computer, electronic, or plumbing] of the Site for Installation. Owner is responsible for ensuring that the Site is prepared in accordance with the specifications provided by Artist. Artist will collaborate with Owner's consultant or building supervisor to obtain all permits necessary for the Installation of the Artwork. Owner will pay for and obtain all permits and licenses necessary for preparation of the Site and for the Installation of the Artwork at the Site.

c. Any miscalculations that are due to error of the Artist or his subcontractors may cause delay in preparation of the Site and/or installation of the Artwork, and Artist will bear the cost, if any, of correcting such miscalculations.

d. Materials chosen for the Artwork should take into consideration Owner's desire that the Artwork be easily maintained and durable. The materials selected should be as flexible as possible to technological advances.

e. Upon completion of Plans, Artist will submit the Plans to Owner for approval. Owner shall review the Plans and give approval or disapproval of the same within ten (10) business days following receipt of the Plans. If Owner approves the Plans, Owner shall make the payment as indicated in Exhibit A, and Artist shall proceed with Fabrication. Upon approval of the Plans, that portion of the Plans pertaining to the Fabrication of the Artwork shall be added to and hereby incorporated into the Design specifications set out in Exhibit B to this Agreement. That portion of the Plans pertaining to preparation of the Site and Installation shall be added to this Agreement as Exhibit C and incorporated by this reference.

f. If Owner disapproves the Plans as submitted, Owner shall indicate the nature and reason(s) for the disapproval in writing to Artist within ten (10) business days. Upon receipt of the notification of Owner's disapproval, Artist shall have ten (10) business days, or longer if mutually agreed, to address Owner's reasons for disapproval and resubmit the Plans. Owner shall then have another ten (10) business days to review the resubmitted Plans. If Owner approves the Plans, Owner shall make the payment as indicated in Exhibit A, and Artist shall proceed to Fabrication. If Owner disapproves the Plans as resubmitted, Owner and Artist shall meet to discuss whether further work will cure Owner's concerns and if so, a reasonable time frame within which to accomplish the cure. If not, then Owner shall pay any out-of-pocket costs incurred by Artist in the course of preparing the Plans and terminate this Agreement. In the event of termination, all intellectual property regarding the Design remains with Artist, and Owner may not use Artist's Design or any derivative thereof.

This is where we get into the nitty gritty of putting the artwork together. It cannot be emphasized enough how important it is to involve a reliable fabricator who has experience creating what you want. While it is oftentimes attractive to go with the least expensive bid on fabrications, experienced public artists will tell you that this is almost always the wrong choice. Make sure your fabricator knows the materials (and pricing reflects an understanding of the market and whether the materials are likely to substantially change in price over the course of the project) and how to work with those materials.

4. <u>FABRICATION</u>

a. <u>ARTWORK SPECIFICATIONS</u> Artist will Fabricate the components that when installed will be the completed Artwork ("Artwork Components"), or cause them to be Fabricated, in substantial conformity with the Design and Plans approved by Owner as set forth in Exhibit B.

b. <u>NOTIFICATION OF COMPLETION</u> Artist will notify Owner in writing pursuant to Paragraph 27 below when the Artwork Components are ready for delivery and installation. Upon receipt of notice, Owner will have ten (10) business days to inspect the Artwork Components for conformity with the structural requirements and to give approval or disapproval of the Artwork.

While it is ideal if the owner can actually go to the place of fabrication and see the components in person, when time and/or distance make a personal visit difficult, often photos will suffice. Emailing photos to the owner and receiving approval via email is usually an acceptable way of establishing satisfactory completion and approval to move forward to the next steps.

i. If Owner gives approval, and such approval shall not be unreasonably withheld, Artist shall receive payment pursuant to Exhibit A and will proceed with Delivery and Installation of the Artwork Components.

ii. If Owner disapproves the Artwork Components, Owner shall provide Artist written notice of such disapproval within ten (10) business days. Artist shall have ten (10) business days, or longer if mutually agreed, to address Owner's reasons for rejection of the fabricated Artwork Components. Owner shall then have another ten (10) business days to review the Artwork Components.

If Owner approves the Artwork Components, Owner shall make the payment as indicated in Exhibit A, and Artist shall proceed with Delivery and Installation.

iii. If Owner again disapproves the Artwork Components as fabricated, the parties agree to work together in good faith to resolve the situation and reach a mutually agreeable solution. If the parties are unable to agree on a solution, either party may choose to terminate this Agreement. Owner shall be responsible to pay Artist for all out-of-pocket expenses up until the time of termination. Artist shall retain the fabricated work and may at his sole option elect to destroy or resell the Artwork. All intellectual property associated with the Design remains with Artist, and Owner may not use Artist's Design or any derivative thereof.

5. CHANGES Changes that do not affect the artistic integrity of the Artwork may occur or be requested at anytime during the course of this Agreement. Minor changes in materials and color may be made at the discretion of Artist for the refinement of the Design of the Artwork. The other party will approve any significant changes to the Artwork by either Artist or as requested by Owner in writing. For purposes of this Agreement, a "Significant Change" will mean any change, including, but not limited to, a change in the scope, design, color, size, or material of the Artwork, which affects cost, installation, site preparation, maintenance, and concept as represented in the Design.

a. If Artist wishes to make a Significant Change to the Artwork, he will notify Owner of the Significant Change in writing at the address provided in Paragraph 27. Owner will provide a written response within ten (10) calendar days.

b. If Owner accepts Artist's request for Significant Change, Owner's written indication of acceptance should include a complete statement of the scope of the accepted changes and any applicable changes to costs.

ANNOTATED ARTWORK COMMISSION

c. If Owner rejects Artist's request for Significant Change, the parties agree to work together in good faith to resolve their lack of agreement and reach a mutually agreeable solution. If the parties are unable to agree on a solution, either party may choose to terminate this Agreement. Owner shall be responsible to pay Artist for all out-of-pocket expenses up until the time of termination. Artist shall retain the fabricated work and may elect to destroy or resell the Artwork. All intellectual property associated with the Design remains with Artist, and Owner may not use Artist's Design or any derivative thereof.

d. If the Owner requests a Significant Change, Artist shall provide Owner a written response within ten (10) business days as to whether he feels the requested Significant Change is artistically appropriate, and if so, the feasibility and cost associated with such requested Significant Change. Owner will then have five (5) business days within which to approve or disapprove the terms of implementing such Significant Change.

e. If Owner rejects Artist's terms for implementing the requested Significant Change, the parties agree to work together in good faith to resolve their disagreement and reach a mutually agreeable solution. If the parties are unable to agree on a solution, either party may choose to terminate this Agreement. Owner shall be responsible to pay Artist for all out-of-pocket expenses up until the time of termination. Artist shall retain the fabricated work and may at his sole option elect to destroy or resell the Artwork. All intellectual property associated with the Design remains with Artist, and Owner may not use Artist's Design or any derivative thereof.

"Significant Changes" may also be referred to as "Material Changes." Either way, this is a somewhat subjective standard that may need to be carefully navigated by the two parties. Generally speaking, there are two main areas of possible tension: if either party feels that a proposed change seriously affects the aesthetics of a project, or if the proposed change substantially impacts the budget for the project. In either case, a conversation is in order and more often than not will result in a mutually acceptable solution.

6. <u>DELIVERY</u>

a. Upon completion of Fabrication, and as long as all Exhibit A payments are current, Artist or Artist's agent(s) will pack, crate, insure, transport, and deliver the Artwork Components to the Site in conformance with the delivery schedule set forth in Exhibit A ("Delivery").

b. <u>ACCEPTANCE</u> Upon Delivery of the Artwork Components to the Site, unless otherwise agreed by the parties, Owner will have a reasonable opportunity to inspect the Artwork Components for defects prior to acceptance. Upon determining that (i) the Artwork components are in conformance with the specifications set forth in Exhibits A and C and (ii) Artist is in substantial compliance with the other terms of this Agreement which Owner has not waived, Owner will accept the Artwork Components. If, within five business days from the day of Delivery, Owner has not raised any objections to the Artwork as delivered, the Artwork will be deemed accepted. In the event that Owner notifies Artist within five business days that the Artwork is defective and/or does not conform in some way to the terms as set forth in this Agreement, Artist will have a reasonable opportunity to cure any defects.

c. <u>DELAY</u> In the event that Owner is not ready for Delivery in accordance with Exhibit A, and wishes Delivery to be delayed, Owner will be responsible for the actual cost of storing the Artwork, if any, and any associated cost of storing the Artwork Components until such time as the Owner is ready for Delivery, including demobilization and remobilization costs.

Getting the owner to promptly inspect the delivery and accept the artwork can be tricky. Often owners do not want to be held to a time frame for acceptance. However, as acceptance of the delivery generally serves to transfer risk of loss from the artist to the owner, the artist is usually eager to get the owner to inspect right away. Prompt inspection makes it easier to determine if there was any damage to the artwork in transit. If inspection is not prompt and there is damage, there is often a dispute over where that damage occurred and who is responsible. This is why it is always in the best interest of the artist to confirm that the owner is ready for delivery of the artwork and that the owner or a representative of the owner will be available to receive delivery.

ANNOTATED ARTWORK COMMISSION

7. SITE AND INSTALLATION

a. SPECIFICATIONS Owner shall prepare the Site, and Artist will install the Artwork in accordance with the schedule and specifications for Installation as attached hereto in Exhibit C and incorporated into this Agreement. The Site will be available for installation at Artist's reasonable convenience as coordinated with Owner.

b. SITE, SITE PREPARATION, AND ACCESS Owner will be responsible for all expenses, labor, and equipment necessary to prepare the Site for Installation as detailed in Exhibit C. Artist and his designated assistants will have free access to the Site at all times during the Installation. Artist will be responsible for inspecting the Site prior to Installation to verify that the Site has been properly prepared to receive the Artwork. By installing the Artwork, Artist accepts the Site as prepared properly and in accordance with the details specified in Exhibit C. If at any point during Installation, Artist or Artist's subcontractors discover a problem with the Site, work must immediately stop, and Owner must be notified. Unless the problem is due to Artist's miscalculations, fabrication deficiencies, or other failure to comply with the Design as approved, Owner will promptly address the Site problem so that Artist may recommence Installation as soon as possible. Artist or Artist's subcontractors are responsible for maintaining a clean Site during Installation and will ensure that the Site is cleaned up upon the completion of Installation. Artist is responsible for complying with all house rules provided by Owner's building supervisors.

c. DELAY In the event that Owner is not ready for Artist to begin Installation, and wishes to delay Installation, Owner will be responsible for the actual cost of storing the Artwork and any associated cost of storing the Artwork until such time as the Owner is ready for Installation. If the Artwork is being stored at the Site, Owner's responsibility for making all storage arrangements, including, but not limited to, keeping the Artwork safe from any damage during

storage and mobilization and demobilization if done by Owner's employees or subcontractors.

Two especially important considerations in this section: responsibility for the site, and what happens in the event of delay.

With regard to the site, the contract should clearly set out who is responsible for ensuring the site meets established requirements. However, if the artist, who is not responsible for site preparation, accepts the site as prepared and begins installation without raising any objections to the improperly prepared site, the artist may then become responsible for the condition of the site and any resulting problems.

Delays are not at all uncommon when it comes to construction projects. The exception is those projects that move forward on schedule the whole way through. Thus, it is a good idea to be clear about how scheduling changes are to be handled. Generally, if the delay is due to the owner being behind schedule, it should be the responsibility of the owner to provide and/or pay for the costs of storing the artwork until the site is ready for delivery and installation. In addition to actual storage costs, don't forget there are other costs incurred when there is a delay: additional insurance, additional transportation and mobilization and demobilization expenses for crews that were scheduled to work on the installation and have to be rescheduled.

8. FINAL APPROVAL AND ACCEPTANCE Upon completion of Installation, unless otherwise agreed by the parties, Owner will have a reasonable opportunity to inspect the Artwork for defects prior to acceptance. Upon determining that (i) the Artwork is in conformance with the specifications detailed in this Agreement and all pertinent Exhibits; and (ii) Artist is in substantial compliance with the other terms of this Agreement which Owner has not waived, Owner will accept the Artwork ("Final Acceptance") and make the final payment pursuant to the terms set forth in Paragraph 2 of this Agreement. If, within ten (10) business days from the day installation is complete, Owner has not raised any objections to the Artwork as installed, the Artwork will be deemed accepted. In the event that Owner notifies Artist within ten (10) business days that the Artwork or the Installation is defective and/or does not conform in some way to the terms as set forth in this Agreement, Artist will have a reasonable opportunity to cure any defects.

Often, owners are reluctant to have an automatic acceptance kick in if they don't raise objections within a particular time frame. This is certainly a point that is negotiable, but you need to keep in mind that until final acceptance, the artist is likely responsible for the Artwork. If damages occur between the time of delivery and the time of acceptance,

ANNOTATED ARTWORK COMMISSION

there may be a dispute as to who is responsible for those damages. It is always best to make acceptance as quick as possible to avoid such possible disputes.

9. <u>MAINTENANCE MANUAL</u> Within ten (10) business days of Final Acceptance of the Artwork, Artist will provide Owner with written instructions for appropriate maintenance and preservation of the Artwork (the "Maintenance Manual").

This manual should be as detailed as possible and include not only suggested maintenance techniques but also any pertinent information about the materials used. If applicable, the manual should also explain how to determine when and how often maintenance work needs to be done on the artwork.

10. <u>REPRESENTATIONS AND WARRANTIES</u>

a. <u>ARTIST'S WARRANTIES</u> Artist warrants that:

i. Artist is the sole author of the Artwork and that Artist is the sole owner of any and all copyrights pertaining to the Artwork or has obtained the appropriate permissions and licenses to incorporate the works of others.

ii. The Artwork is an original creation and the result of the artistic efforts of Artist and that it will be installed free of any liens, claims, or other encumbrances of any type. Further, Artist has not knowingly infringed upon any copyright or trademark.

iii. The Artwork is unique and an edition of one (1) and that Artist will not execute or authorize another party to execute another work of the same or substantially similar design and dimension as the artwork commissioned pursuant to this Agreement. Artist may create works that use or incorporate various individual art elements that comprise the Artwork, so long as the work using or incorporating such elements (1) does not consist predominantly of such elements, (2) is not the same or substantially similar in image, design, dimensions, and materials as the Artwork, and (3) is not displayed in an environment that is the same or substantially similar to the environment in which the Artwork is to be displayed at the Site.

iv. The Artwork will be free of defects in workmanship and materials. In the event that any defects become apparent in the workmanship or materials within _____ year(s) of Installation, Artist will remedy any defects at Artist's expense. Any inherent defects in the work that are specifically identified in the Design and approved by Owner are not warranted.

v. The Artwork is composed of several elements that will need to be maintained and/or replaced periodically. These elements are: _____.

vi. The Artwork will not pose a danger to public health or safety in view of the possibility of misuse, if such misuse in the manner that was reasonably foreseeable at any time during the term of this Agreement.

vii. Artist shall not be responsible for deterioration of the Artwork materials due to failure of Owner to properly maintain according to the Maintenance Manual.

viii. To the extent the Artwork incorporates products covered by a manufacturer's warranty, Artist shall provide copies of such warranties to Owner.

ix. Artist will collaborate with Owner or Owner's representative to obtain all permits necessary for the Installation of the Artwork.

Of course, there may be more or different warranties to be made, but the key is that this section verifies originality and other attributes of the work that give it value. Normally, the warranty of the work is for anywhere from one to three years. You may also be passing along warranties that come with underlying materials incorporated into the artwork (lights, electrical components, computer parts, solar panels). Remember: You can only pass along the warranties you actually have from the manufacturer. Any warranty that exceeds the manufacturer's warranty will come out of your pocket!

b. OWNER'S WARRANTIES Owner warrants that:

i. The Site is prepared in conformance with the specifications set forth in this Agreement and Exhibit C and that the foundation

or any attachment device or structure provided and installed by Owner or its agents for the Artwork is structurally sound and in conformance with the specifications presented to Artist.

ii. Owner will pay for and obtain all permits and licenses necessary for the Installation of the Artwork at the Site. Further, Owner will inform Artist of any and all requirements for Installation of the Artwork at the Site.

There may be other appropriate warranties for the owner to give, but generally these are the biggies.

11. INTELLECTUAL PROPERTY OWNERSHIP

a. GENERAL Except as provided in this Agreement, Artist retains all copyrights and other intellectual property interests in the Artwork and in the Design, drawings, sketches, prototypes, and other materials for the Artwork. Artist will place a copyright notice on the Artwork and may, at his option, register the copyright with the Library of Congress.

b. REPRODUCTIONS Artist hereby grants to Owner the non-exclusive right to make, and to authorize the making of, photographs and other two-dimensional reproductions of the artwork for any Owner-related purposes, including, but not limited to, educational, advertising, marketing, public relations, business promotion, any documentation of Owner's art collection, or other noncommercial purposes. This license does not include the right to create three-dimensional works or to reproduce the Artwork for merchandising purposes. Any rights to merchandise the Artwork must be established pursuant to a separate agreement with the Artist.

c. THIRD PARTY INFRINGEMENT In the event of an infringement by a third party of the copyright and other intellectual property interests in the Artwork, Owner and Artist shall have the right to sue jointly for the infringement and, after deducting the ex-

penses of bringing suit (to be borne equally), to share equally in any recovery. If either party chooses not to join in the suit, the other party shall have the right, but not the obligation, to institute suit. All costs, including attorneys' fees, with respect to such suit, shall be advanced by the party electing to initiate such suit, and all of the proceeds thereof shall belong solely to such party, whether by way of settlement, judgment, or otherwise. If either Owner or Artist unilaterally institutes any such legal proceeding, then the moving party shall have the right to settle such action upon such terms as that party may agree to is in its sole business discretion. If no such legal proceeding is instituted, Owner and the Artist shall mutually agree upon the terms of any settlement to be made with any third parties who commit or participate in any act of infringement. If any legal action is instituted under the provisions of this paragraph, whether jointly or unilaterally, then Owner and the Artist will fully cooperate with each other in the prosecution of such action.

The issues of copyright ownership and rights to reproduce the work can be thorny. Normally, the artist gets to retain ownership but gives the owner some limited rights to use the artwork and images of the artwork for specific purposes. As long as the owner's use is somewhat related to the purpose of the building and/or the reason for commissioning the work in the first place, like marketing a commercial space for lease with a photo of the artwork in front, that's acceptable. However, if the owner uses the work in a way that generates additional income directly related to the artwork, like making t-shirts with pictures of the artwork on the front and selling them online, that is an unrelated use that must be separately negotiated. You can define these parameters however you want to as long as both parties agree.

12. CREDITS

a. LABEL A plaque of reasonable dimensions provided by Owner, identifying Artist, the title of the Artwork, and the year it was completed will be publicly displayed outdoors in a place nearby the buildings that is publicly accessible and obvious.

b. ARTIST'S CREDIT Owner agrees that unless Artist requests to the contrary in writing, all references to the Artwork and all reproductions of the Artwork will credit the Artwork to Artist.

ANNOTATED ARTWORK COMMISSION

c. OWNER'S CREDIT Artist agrees that all formal references to the Artwork will include the following credit line: "From the collection of _____."

Sometimes a label is not possible or appropriate, but whenever possible, public attribution should be given to the artist. Likewise, the artist should give credit to the commissioning party when using images of the artwork to promote the artist's business.

13. MAINTENANCE, REPAIR, AND RESTORATION [Artist's budget for the Artwork includes $_____ as the cost of maintenance and conservation of the Artwork for _____ years following installation (the "Maintenance Budget").] [Upon Transfer of Title of Artwork to Owner, Owner shall be responsible for all costs related directly and indirectly to the maintenance, repair, and restoration of the Artwork for the life of the Artwork.]

As artwork ages, maintenance issues become a more probable source for dispute. Oftentimes, no thought is given at the outset of a project as to how maintenance will occur over time. Maintenance costs money. The money must come from somewhere. Either the artist budgets a maintenance fund into the project, or the owner accepts the responsibility of the cost and actual implementation of maintenance routines. The point here is that maintenance must be considered up front, and a plan must be in place from the beginning in order to avoid problems down the road.

14. MODIFICATION, DESTRUCTION, OR REMOVAL OF ARTWORK

a. Owner shall notify Artist in writing of any proposed significant alteration of the Site that would affect the intended character and appearance of the Artwork, including removal or relocation of the Artwork that might result in the Artwork being destroyed, distorted, or modified. The Owner shall make a good faith effort to consult with the Artist in the planning and execution of any such alteration. The Owner shall make a reasonable effort to maintain the integrity of the Artwork. If the Artwork cannot be successfully removed or relocated as determined by the Owner, the Artist may disavow the Artwork or have the Artwork returned to the Artist at the Artist's expense.

b. The Artwork may be removed or relocated or destroyed by the Owner should the Artist and the Owner not reach mutual agree-

ment on the removal or relocation of the Artwork after a period not to exceed ninety (90) days after written notice to the Artist. During the ninety-(90)-day period, the Parties shall engage in good faith negotiations concerning the Artwork's removal or relocation.

c. In the event of changes in building codes or zoning laws or regulations that cause the Artwork to be in conflict with such codes, laws, or regulations, the Owner may authorize the removal or relocation of the Artwork without the Artist's permission. In the alternative, the Owner may commission the Artist by a separate agreement to make any necessary changes to the Artwork to render it in compliance with such codes, laws, or regulations.

d. If the Owner reasonably determines that the Artwork presents imminent harm or hazard to the public, other than as a result of the Owner's failure to maintain the Artwork as required under this Agreement, the Owner may authorize the removal of the Artwork without the prior approval of the Artist.

e. Because the work is site-specific in nature, Owner shall not have the right to donate or sell the Artwork at any time.

f. This clause is intended to replace and substitute for the rights of the Artist under the Visual Artists' Rights Act ("VARA") [and the California Art Preservation Act (California Civil Code §987)] to the extent that any portion of this Agreement is in direct conflict with VARA [or CAPA rights]. The parties acknowledge that this Agreement supersedes that law to the extent that this Agreement is in direct conflict with VARA [or CAPA].

Waiving rights granted by the Federal Visual Artists' Rights Act and/or any state rights such as the California Art Preservation Act is fine as long as there is language to effectively replace those laws. Artwork needs to be treated with respect, and the artist's intent should be considered at all times. The specifics of what is agreed to can differ with each contract and depends to a large degree on the nature and scale of the artwork.

ANNOTATED ARTWORK COMMISSION

15. <u>RESALE OF THE ARTWORK</u> If Owner sells the Artwork as a fixture to real property, and if the resale value of the Artwork is not itemized separately from the value of the real property, the parties agree that the resale price of the Artwork shall be presumed to be less than the purchase price paid by Owner under this Agreement. Thus, Owner has no obligation to pay resale royalties pursuant to California Civil Code §986 or any other law requiring the payment of resale royalties. If Owner sells the Artwork as an individual piece, separate from or itemized as part of a real property transaction, Owner shall pay to Artist a resale royalty to the extent required by law, based upon the sale price of the Artwork.

16. <u>TRANSFER OF TITLE</u> Ownership of the Artwork, as defined by this Agreement, will pass to Owner upon Final Acceptance of the Artwork and receipt by Artist of final payment as set out in Exhibit B.

17. <u>RISK OF LOSS</u> Artist bears the risk of loss or damage to the Artwork for any loss or damage to the Artwork that results from Artist's or Artist's agents' actions, until Final Acceptance following Installation, at which time the risk of damage to, or loss of, the Artwork passes to Owner.

It is important that Transfer of Title and Risk of Loss be considered separately. The artist should hold the title until final payment is received. Otherwise, the artist has no way to assure payment. Risk of loss, however, should transfer when control of the work transfers. In any case, both parties should make sure that there is adequate insurance coverage to compensate for any damage that could occur to the artwork at any point along the way.

18. <u>INDEMNIFICATION</u> Owner agrees to indemnify and hold harmless Artist, his successors, and assigns from any claim or suit arising or resulting from the breach by Owner or its agents of any contractual obligations set forth in this Agreement. Artist agrees to indemnify and hold harmless Owner, its successors, and assigns from any claim or suit arising out of a breach by Artist of any contractual obligations set forth in this Agreement.

Ideally, indemnification language is mutual so that each party has the same protection and assurances against liability caused by the other party. But keep in mind that espe-

cially when one party is a municipality or any other non-private entity, it may be difficult to secure a mutual indemnification. This issue need not be a deal-breaker but is definitely something to discuss and keep in mind as you move through your contract negotiations.

19. TIME OF THE ESSENCE Artist understands and acknowledges that time is of the essence in this Agreement. In the event that any component necessary for the timely installation of the Artwork is missing or damaged, Artist shall take sole responsibility for ensuring that such component is promptly replaced and installed.

20. INSURANCE

a. ARTIST'S INSURANCE Artist agrees to insure the Artwork against loss by fire, theft, or any damage occurring during Fabrication, storage, transportation, Delivery, and Installation of the Artwork until midnight of the day on which the title passes or the final payment is received, whichever is later. A certificate of insurance evidencing such coverage will be furnished to Owner upon request. All policies of insurance will name Owner or Owner's designee as a loss payee.

b. OWNER'S INSURANCE Owner will procure and maintain all-risk insurance on the Artwork naming Artist as a loss payee in the amount of the full Contract Amount under this Agreement from the time the Artwork, or portions of the Artwork, are delivered to the Site and until midnight of the day that title passes to Owner or final payment is received by Artist, whichever is later. A certification of insurance evidencing such coverage will be furnished to Artist upon request.

c. WORKERS COMPENSATION Owner acknowledges that Artist has no employees and is therefore under no obligation to procure Worker's Compensation, Accident and Unemployment Insurance according to the statutory requirements of the appropriate jurisdiction(s). Artist agrees to bind contractually under written agreement any United States subcontractor of Artist retained for fabrication of the Artwork to comply with appropriate Worker's Compensation requirements.

ANNOTATED ARTWORK COMMISSION

d. COMMERCIAL GENERAL LIABILITY INSURANCE Artist will maintain Commercial General Liability coverage with insurance carriers approved by Owner in the following minimum amounts:

FORM OF COVERAGE	LIABILITY LIMITS
Comprehensive General Liability	$1,000,000 per occurrence combined single limit for bodily injury, including personal injury and property damage.
Automobile Liability	$1,000,000 per accident combined single limit for bodily injury and property damage.
Umbrella Liability	$1,000,000 per occurrence and aggregate.
Fine Art and/or Property Insurance	The greater of the fair market value and replacement cost, but in no case less than the Contract Amount.

Artist will require each subcontractor under written agreement to procure and maintain similar insurance coverage. Artist will not commence Installation under this Agreement until Owner has received Artist's insurance certificates for the coverage listed above.

Always send insurance coverage requirements to your insurance agent to make sure that you can obtain the coverage. Who knows? Maybe you're already covered!

21. SUSPENSION OF PERFORMANCE BY EXCUSED DELAY Artist shall be entitled to an extension on the performance schedule in the event that there are delays caused by events beyond the reasonable control of Artist or Artist's subcontractors, including, but not limited to, actions or negligence of Owner; Owner's agents, employees, separate contractors, or their employees or agents; by changes in the Scope; unreasonable delays by governmental authorities in scheduling inspections or conducting review or issuing approvals; fire, unusual and unavoidable delay in deliveries, or unavoidable casualties or by adverse weather or unreasonable delays by Owner or Owner's agents in responding to Artist. Excused Delays shall not include delays or interruptions due to labor disputes arising from the decision of Artist or his subcontractors to use non-union labor or to schedule concurrent work by non-

union and union labor crews, or arising from jurisdictional labor disputes. In the event of Excused Delay, Artist shall be entitled to an extension measured by the number of days that performance is actually delayed.

22. EXCUSE OF CONTRACTUAL OBLIGATIONS BY FORCE MAJEURE The parties will be excused from performing under this Agreement if performance is prevented by a condition beyond the control of the parties such as acts of God, war, civil insurrection, government action, or public emergency but only for as long as such unforeseen occurrence exists. Both parties will take all reasonable steps to assure performance of their contractual obligation when the unforeseen occurrence has ceased to exist, but resumption of performance will be subject to negotiation between the parties if more than one (1) year has passed since suspension of obligations under this Agreement or there are substantially changed circumstances.

Any time there is an interruption in the project by circumstances out of anyone's control, it makes sense to be reasonable and accommodating. Figuring out how best to get back on track is in everyone's interest.

23. DEATH OR INCAPACITY OF ARTIST In the event of Artist's physical incapacity or death prior to the completion of the Artwork, all payments made up to the point of incapacity or death will be retained by Artist, and all work performed to date of incapacity or death will be compensated. Upon payment to compensate Artist or Artist's estate for all work performed to the date of incapacity or death, the incomplete Artwork and any materials paid for by Owner will become the property of Owner. However, if the Artwork is substantially designed and/or completed, and it is feasible for the work to be fully completed without undue delay, Owner may elect to proceed under the terms of this Agreement with the written consent of Artist's estate. In the event that Owner elects to proceed with the completion of the Artwork and has obtained permission from the Artist, or his estate, all remaining work to be completed in accordance with this Agreement will be delegated to: _____.

ANNOTATED ARTWORK COMMISSION

Often, the largest part of the artist's work is finished after the design has been completed and approved. The rest of the job for the artist is to oversee fabrication and installation. In the event of death or incapacity, the contract need not be terminated. Usually, there is another person or team who is familiar enough with the artist's work that the artwork can be completed and installed. This saves the owner from having to start from scratch and pay twice for the artwork, and it protects the artist's interests as well, as artists generally count on the income from each project to cover expenses until the next project. That being said, it is normally not okay to have a third party step in to finish the artwork and cut the artist out unless the artist or artist's representative has agreed to this arrangement.

24. ASSIGNMENT Artist will not assign, transfer, or subcontract the creative and artistic portions of the Artwork to another party without the prior written consent of Owner. Owner will not assign or transfer the title of the Artwork or any interest therein without thirty (30) calendar days prior written notification to Artist. This Agreement will be binding against all assignees, heirs, or successors in interest of Owner.

25. GOVERNING LAW This Agreement and all matters pertaining thereto will be construed and enforced according to the laws of the State of _____.

26. NOTICES All notice, submittals, requests, and reports required under this Agreement will be hand delivered or sent by certified mail as follows:

FOR ARTIST

FOR OWNER

WITH COPIES TO

It may be appropriate to copy your attorney, an art consultant involved in the project, or other representative.

Notice is deemed to have been received either upon the date recipient signs the return certificate, or five (5) days after the notice is mailed to recipient, whichever is sooner. A change in the designation of the person or address to which submittal, requests, notices, and reports will be delivered is effective when the other party has received notice of the change by certified mail. Because there may be situations following the completion of this Agreement pursuant to which Owner wishes to notify Artist, it is Artist's responsibility to ensure that Owner has current contact information on file for Artist during the life of the Artwork.

27. DISPUTE RESOLUTION In the event of any disputes arising from the terms of or performance under this Agreement, the parties shall first attempt resolution through good faith discussion and/or mediation. If discussion and/or mediation do not resolve the dispute(s), both parties agree to [binding/non-binding arbitration in the State of _____.] [The parties will choose an arbitrator from AAA or another mutually agreed upon arbitrator. If the parties cannot agree upon an arbitrator, each party will select one arbitrator, and the two selected arbitrators will mutually agree upon a third arbitrator. The three will serve collectively as a three-(3)-person panel to resolve the dispute.] The Parties may resort to litigation and equitable relief to resolve disputes that still exist after mediation [and/or arbitration]. In addition, either Party may seek equitable relief (injunction and/or specific performance) at any time when immediate enforcement or cessation of performance under this Agreement is required to avoid foreseeable damages to relief-seeking Party's interests, including, but not limited to, intellectual property interests.

ANNOTATED ARTWORK COMMISSION

There are many options for dispute resolution. The language here anticipates arbitration. Arbitration can be binding or non-binding. Arbitration can also be left out as an option. The main point here is to make sure there is a clear path for dispute resolution. Beginning that journey should always start with the least expensive, emotional, and time-consuming, option: a good faith discussion. Beyond that, you can choose to require mediation, arbitration, or simply go straight to court. This is an important area, among all the others, to discuss with your legal counsel.

28. JURISDICTION Unless otherwise agreed, any litigation shall take place in the state or federal courts located in the State of _____ , and the Parties will accept the exclusive jurisdiction of these courts. Each Party agrees to service of process through the procedure defined for Notices in Paragraph 27 above.

29. ATTORNEY FEES AND COSTS There will be no recovery of fees or costs for mediation. The prevailing Party in any arbitration or court action or proceeding shall be entitled to receive from the other Party all costs and expenses, including reasonable attorneys' fees, incurred by the prevailing Party in connection with such action or proceeding.

30. ENTIRE AGREEMENT This Agreement constitutes the entire agreement between the parties and supersedes all previous agreements in this matter. There are no other written or oral agreements, representations, or understandings with respect to the subject matter of this Agreement. This Agreement and its terms may be amended, modified, or waived only by written agreement, signed by both parties.

Do not count on any oral promises that are made outside the words of the contract. This clause will prevent you from relying on anything but what's written.

31. <u>EXECUTION OF AGREEMENT</u> This Agreement may be executed in counterpart and by facsimile.

<u>ACCEPTED AND AGREED</u>

<u>OWNER</u>
By: _____
Title: _____
Date: _____

<u>ARTIST</u>
By: _____
Title: _____
Date: _____

ANNOTATED ARTWORK COMMISSION

EXHIBIT A: PERFORMANCE AND PAYMENT SCHEDULE

Approximately
Date _____
Percent Amount _____
Work _____

TOTAL $ _____

This is where all milestones should be clearly set out with anticipated dates of completion, as well as percent and amount of budget to be paid. If appropriate, a PDF of the budget can also be attached for further detail.

Important considerations include what amounts are due to fabricators and when. Artists generally are not in a position to be out of pocket very long, if at all, and the payment schedule should take this into account. This can be a deviation from how commissioning parties are used to paying for service and construction, so it can be a difficult issue on which to prevail. Nevertheless, it can mean the difference between an artist being able to produce an extraordinary piece or having to stick with something safe for budgetary reasons.

Another element to carefully plan is the time for completion of each milestone. Clear communication between the owner and artist is paramount so that the artist is clear about the owner's construction schedule (if any) and owner is clear about the artist's fabrication schedule. These two schedules must coordinate! Miscommunications in this area can create a scheduling nightmare.

EXHIBIT B: APPROVED CONCEPTUAL DESIGN AND FABRICATION PLANS

These documents can be attached as they are completed during the course of the contract performance. They may also be augmented or amended as projects often change during the course of performance.

EXHIBIT C: INSTALLATION AND SITE SPECIFICATIONS

These specifications are crucial to the installation process and must be carefully developed with the input of all appropriate experts, such as engineers and/or architects. Once established, they must be closely adhered to as each aspect of site preparation impacts the installation.

If at any point the site conditions do not seem to be meeting established standards, it is imperative that the artist and any subcontractors stop work immediately to address these deviations. A problem may seem small, but as you proceed with the addition of other project elements, those problems will likely be amplified and become untenable and/or make the project unacceptable in the eyes of the owner. If work is stopped immediately upon discovery of any imperfections in the site preparation, such imperfections can be addressed, corrected, and hopefully attributed to the appropriate party. If work continues by the artist or artist's subcontractors, it will become the responsibility of the artist whether or not the underlying problem was originally caused by artist. Failure to immediately address site concerns may preclude artist's ability to do so later.

ANNOTATED ARTWORK COMMISSION

8. TRANSFER OF TITLE

This Transfer of Title ("Transfer") is made this _____ (Date) between the following parties (the "Parties"):

_____ ("Artist")

and

_____ ("Owner")

WHEREAS pursuant to a separate agreement (the "Commission"), Owner contracted with Artist for the [design, fabrication, delivery, and installation] of _____ (the "Artwork"); and

WHEREAS the Commission is complete and final payment and final approval have been given by Owner; and

WHEREAS the Parties wish to complete the transfer title of the Artwork to Owner,

It is hereby agreed in exchange for good and valuable consideration as set forth below that:

1. PAYMENT AND TRANSFER OF TITLE Artist hereby acknowledges receipt of final payment pursuant to the Commission, and execution of this Transfer, all right, title, and interest to the physical Artwork, excluding copyright interests as detailed in paragraph 2 below, is hereby conveyed to the Owner.

2. COPYRIGHT Except as provided in this Transfer or the Commission, Artist retains all copyrights and other intellectual property interests in the Artwork and in the design, drawings, sketches, prototypes, and other materials for the Artwork.

TRANSFER OF TITLE

3. <u>REPRODUCTIONS</u> Consistent with the terms of the Commission, Artist confirms granting to Owner the right to make, and to authorize the making of, photographs and other two-dimensional reproductions of the artwork for educational, public relations, arts promotional, and other noncommercial purposes. If Owner wishes to make reproductions of any other sort or for any other purpose, Owner must obtain separate written permission from Artist.

4. <u>REPAIRS AND MAINTENANCE</u> Owner recognizes that normal maintenance of the Artwork will involve simple procedures and that such maintenance on a regular basis is essential to the integrity of the Artwork. The Owner is responsible for all routine maintenance required on a periodic basis as specified by Artist in the technical and maintenance specifications record. Owner, to the best of its ability, will ensure compliance of this responsibility. Where possible, Artist shall be consulted as to his recommendations regarding repairs and restorations being made during the lifetime of Artist. Upon Artist's death, to the extent practicable, the Owner shall consult Artist's Studio and/or estate. To the extent practicable and in accordance with accepted principles of professional conservation, Artist shall be given the opportunity to accomplish repairs and restorations and shall be paid a reasonable fee for the services.

5. <u>GENERAL TERMS</u>

a. This Transfer contains the full and complete understanding of the parties hereto, and once signed by all Parties, will supersede any prior agreements regarding the subject matter of this Transfer.

b. The Parties agree to execute and/or deliver other documents reasonably necessary to further effect and evidence the terms of this Transfer, as long as the terms and provisions of the other documents are fully consistent with the terms of this Transfer.

c. If any provision of this Agreement is deemed to be invalid or unenforceable in any respect for any reason, the validity and enforceability

of any such provision in any other respect and of the remaining provisions of this Agreement will not be in any way impaired.

d. This Agreement will be governed by and construed exclusively in accordance with the laws of _____ without regard to conflict of laws principles. The venue for any action arising out of this Agreement will be exclusively in _____ County, State of _____ .

e. The costs of mediation will be borne equally by the Parties. In the event of arbitration or other legal action, arising out of, or in any way related to any term set forth in this Transfer, the prevailing Party, in addition to any other relief awarded, will be entitled to recover its reasonable attorneys' fees and costs.

f. All notices, statements, and correspondence sent to the Parties should be addressed to the addresses listed at the beginning of this Transfer.

IN WITNESS WHEREOF, the Parties hereby sign this Agreement effective as of the date first stated above.

OWNER
By _____

ARTIST
By _____

9. FABRICATION AGREEMENT

This Agreement is made this _____ (Date)
by and between _____ ("Artist") located at
_____ and _____ ("Fabricator"),
located at _____ .

WHEREAS Artist is in the business of designing artwork and has been
commissioned by _____ to create _____
(the "Artwork") for _____ ; and

WHEREAS Fabricator is in the business of fabricating
_____ ; and

WHEREAS Artist wishes to have Fabricator fabricate the Work;

NOW, THEREFORE, for good and valuable consideration, the receipt and
sufficiency of which are acknowledged, the parties agree as follows:

1. SCOPE Subject to the terms and conditions of this Agreement, and the
 performance and payment schedule set out in Schedule A attached to
 this Agreement and incorporated by reference, Fabricator shall
 fabricate _____ .
 A detailed description of the Work to be fabricated and specifications,
 along with any previously submitted proposals as applicable, are
 set out in Schedule B attached to this Agreement and incorporated
 by reference.

2. DELIVERY Unless otherwise notified by Artist, delivery shall be made
 to _____ [location] on or before _____ .
 a. Delivery schedule must be confirmed by Fabricator with Artist via
 phone or email prior to delivery.
 b. Fabricator shall be solely responsible for the arrangements,
 oversight, cost, and liability of transportation for the Artwork.

c. Fabricator shall provide insurance for the Artwork during fabrication, shipping, and delivery. Risk of loss for the Artwork shall transfer to Artist only upon formal acceptance of delivery in writing.

3. STORAGE If delivery of work must be delayed due to construction delays, Fabricator will provide storage of the Artwork [for $ _____].

4. LICENSES AND PERMITS Fabricator shall, at Fabricator's expense, obtain and/or provide any licenses, permits, and procedural authorizations required for fabrication and/or delivery of the Artwork.

5. MAINTENANCE Fabricator shall provide Artist with a written document detailing the routine care, long-term care, and any other care requirements necessary to maintain the Artwork.

6. FABRICATOR REPRESENTATIONS AND WARRANTIES Fabricator represents and warrants:
 a. That the Artwork is crafted to the highest standards.
 b. Fabricator shall warrant the fabrication of the Artwork for a period of one (1) year following final acceptance of the Artwork by Artist.
 c. Fabricator shall provide product warranties for all integrated elements that carry a warranty.
 d. Fabricator shall enforce the terms of this Agreement, including, but not limited to, those provisions pertaining to Intellectual Property, Limited License, and Work for Hire with any and all of its subcontractors.

7. INTELLECTUAL PROPERTY Artist retains all right, title, and interest over any intellectual property provided to Fabricator during the course of fabrication, as well as all intellectual property for the Artwork produced pursuant to this Agreement. Unless specifically provided for in writing, Fabricator retains no intellectual property or derivatives thereof in the Artwork.

8. <u>WORK MADE FOR HIRE</u> The Artwork Fabricator is producing pursuant to this Agreement has been specially ordered and commissioned by Artist. Fabricator agrees that the Artwork, or any part thereof, is a "work made for hire" for copyright purposes, with all copyrights in the Artwork and any derivative thereof owned by Artist. Artist will therefore have sole and exclusive control of the Artwork and any derivative thereof. To the extent that the Artwork produced by Fabricator does not qualify as a work made for hire under applicable law, and to the extent that the Artwork includes material subject to copyright, patent, trade secret, or other proprietary right protection, Fabricator hereby assigns to Artist, her successors, and assigns, all right, title, and interest in and to the Artwork, including, but not limited to, all rights in and to any inventions and designs embodied in the Artworks or developed in the course of Fabricator's creation of the Artwork. The foregoing assignment includes a license under any current and future trademarks, copyrights, or patents owned or licensable by Fabricator to the extent necessary to combine the Artwork or Derivative Work thereof with any future works.

9. <u>LIMITED LICENSE</u> Fabricator may use images of the Artwork for non-commercial purposes, including sales brochures, catalogs, and Internet and media publicity. All reproductions shall credit Artist as follows: "© Artist, Year. All Rights Reserved."

10. <u>INDEPENDENT CONTRACTOR</u> Fabricator agrees and understands that all work performed pursuant to this Agreement is on an independent contracting basis, and in no event will Fabricator be considered an employee, partner, or agent of Artist.

11. <u>INSURANCE</u> The risk of loss of the Artwork shall remain with Fabricator for all elements of the Artwork until those elements are delivered to the Artist. All risk insurance on the Artwork, which shall fully protect the Artist's and the Owner's interests, is carried by Fabricator during the period of fabrication and transport. Fabricator shall arrange for Artist to be listed as a Loss Payee on the insurance policy covering

FABRICATION AGREEMENT

the Artwork during fabrication and transport. Fabricator shall carry Comprehensive General Liability insurance in the amount of not less than $1,000,000, combined single limit for each occurrence.

12. NOTICES AND DOCUMENTS Notices required under this Agreement shall be delivered personally or through the certified mail, postage prepaid, to the addresses stated below, or to any other address as may be noticed by a Party:

FOR ARTIST FOR FABRICATOR

_____ _____

_____ _____

Notice shall be deemed effective on the date personally delivered or, if mailed, three (3) days after the postmarked date.

13. ASSIGNMENT This Agreement may not be assigned by Fabricator without the express written permission of Artist.

14. DISPUTE RESOLUTION To the extent that there are disputes with respect to performance under this Agreement, such disputes are not cause for the Fabricator to stop under the Agreement, but will be resolved in due course to the extent possible in accordance with this Section.

a. GOOD FAITH CONSULTATION The Parties to this Agreement will attempt to resolve any problem or dispute arising out of, or related to, this Agreement through good faith consultation in the ordinary course of business.

b. MEDIATION If the Parties are unable to resolve the problem or dispute within thirty (30) days, the matter will be submitted to mediation, or to such other form of dispute resolution as the Parties may then agree to. The mediation will be conducted by a neutral person acceptable to both Parties, and unless other Dispute Resolution procedures are

agreed to, it will be conducted in accordance with the Center for Public Resources Model Procedure for Mediation of Business Disputes.

c. ARBITRATION If mediation is not successful in resolving the entire dispute, any outstanding issues shall be submitted to binding arbitration by a professional arbitrator acceptable to the Parties. The arbitrator will be chosen from a panel of attorneys knowledgeable in the field of art and business law. The Arbitration shall be conducted in accordance with the rules of the American Arbitration Association. Any Party may, without inconsistency with this Agreement, seek from a court any interim or provisional relief that may be necessary to protect the rights or property of that Party pending the selection of the arbitrator (or pending the arbitrator's determination of the merits of the controversy or claim). The prevailing Party at arbitration will be entitled to costs and attorneys' fees.

d. OTHER REMEDIES The Parties may seek equitable relief (injunction and/ or specific performance) at any time when immediate enforcement or cessation of performance under this Agreement is required to avoid foreseeable damages to relief-seeking Party's interests, including, but not limited to, intellectual property interests.

15. GOVERNING LAW This Agreement shall be governed, construed, interpreted, enforced, and performed in accordance with the laws of the State of _____ and the United States of America.

16. VENUE Any legal action or proceedings arising from this Agreement shall be filed and conducted within the State of _____ in the County of _____ . The prevailing party is entitled to recover reasonable costs and attorney fees.

17. DEFAULT The parties agree that in the event one party determines that the other is in default of any of the obligations set out in this Agreement, the non-defaulting party must send the other (defaulting) party

FABRICATION AGREEMENT

specific written notice of such default by certified or registered mail, return receipt requested stating the specific nature of the breach. The breaching party shall have _____ days after receipt of said written notice to cure the breach. In the event the breach is not cured, the non-breaching party may terminate this Agreement by written notice. The breaching party shall be liable for damages caused by such breach and may be subject to any available remedies, including injunctive relief.

18. SEVERABILITY AND NON-WAIVER Should any portion of this Agreement be declared invalid or void for any reason, the remaining provisions shall continue in full force and effect. Failure of either party to enforce its rights under this agreement shall not be construed as a waiver or relinquishment of such rights in the future.

19. ENTIRE AGREEMENT This Agreement sets out the entire understanding of both parties. This Agreement supersedes all prior understandings, communications, and agreements. Any amendments or modifications to this Agreement must be done in a written document signed by both parties.

20. IMPOSSIBILITY OF PERFORMANCE If a situation arises as a result of events beyond Fabricator's reasonable control, which makes performance for Fabricator impossible, Fabricator's obligations shall be waived or delayed as appropriate and mutually acceptable.

21. ADDITIONAL TERMS AND CONDITIONS as passed through from Artist's contract with [commissioning party] are included in this Agreement as Schedule C.

ACCEPTED AND AGREED

ARTIST
Signature _____
Print Name _____
Date _____

FABRICATOR
Signature _____
Print Name _____
Date _____

SCHEDULE A: PERFORMANCE AND PAYMENT SCHEDULE

List all benchmarks and corresponding progress payments to be made. If appropriate, include deadlines in the form of specific dates or periods of time.

PAYMENT

Artist shall pay Fabricator a total fee of $ _____ , to be paid as follows:

a. 25% ($ _____.00) to start

b. 30% ($ _____.00) when _____ 50% done.

c. 30% ($ _____.00) when _____ 100% done.

d. 15% ($ _____.00) when project is delivered and approved by Artist.

SCHEDULE

This project shall begin on _____ and will be completed as follows:

_____ by _____ .

_____ by _____ .

_____ by _____ .

_____ by _____ .

Schedule B: Details of Fabrication

Specifications:

Prior Proposals:

Schedule C: Terms Passed Through from Artist's Contract with Commissioning Party

FABRICATION AGREEMENT

Published by

AMMO

AMMO Books, LLC
www.ammobooks.com

ISBN 978-1-623260-24-8 First edition

Library of Congress Cataloging-in-Publication Data

Conley Odenkirk, Sarah.
 A Surprisingly Interesting Book About Contracts for
 Artists & Other Creatives

2013937771

Edited by Huck Barkin
Designed by Content Object Design Studio, Los Angeles
Illustrations by Joe Biel

Printed in China